COMPLETE STRETCHING

A New Exercise Program for Health and Vitality

MAXINE TOBIAS
AND
JOHN PATRICK SULLIVAN

NEW YORK: ALFRED A. KNOPF
1994

DK

A DORLING KINDERSLEY BOOK

Project Editor
Susannah Marriott

Art Editor
Tina Hill

Managing Editor
Daphne Razazan

Managing Art Editor
Anne-Marie Bulat

Production Controller
Rosalind Priestley

LC 91-58624
ISBN 0-679-73831-2

Reproduction by J. Film Process, Singapore PTE Ltd.
Printed and bound by Wing King Tong Co., Ltd.,
Hong Kong

PUBLISHED MAY 9, 1992
SECOND PRINTING, FEBRUARY 1994

THIS IS A BORZOI BOOK
PUBLISHED BY ALFRED A. KNOPF, INC.

Contents

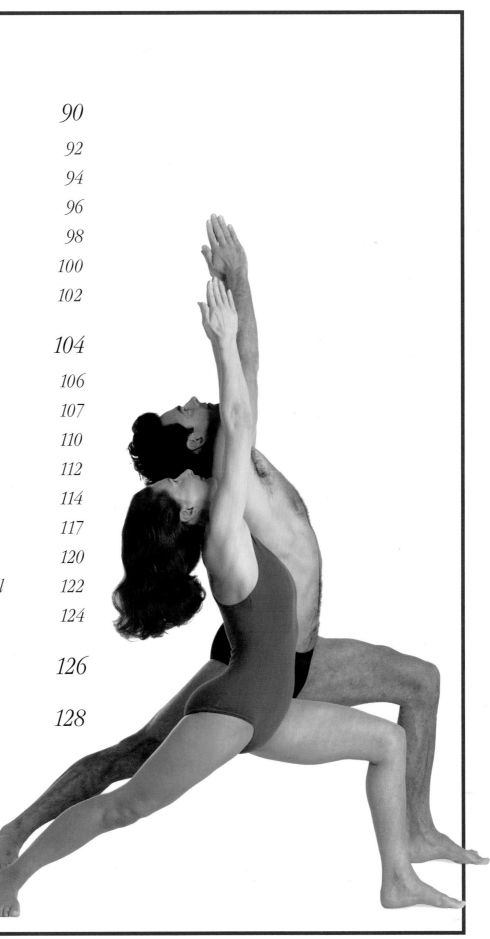

Introduction

STRETCHING IS VITAL for dynamic health and fitness, the foundation of all other activities. John and I believe that stretching unlocks in us all the potential for vitality, creativity, and radiance. Health and energy belong not only to the young; we can all enjoy an active life well into our advanced years by building into our lives an exercise system that cares for our physical well-being with stretches and calms us with deep relaxation. **Complete Stretching** demonstrates how to maximize physical and mental energy, increase flexibility, improve body shape, and enhance relaxation.

STRETCHING INTO HEALTH

The fast pace of life today, economic pressure, and pollution are changing the quality of life. More than ever before, sedentary living affects postural development; over-eating and lack of exercise take a toll on body and mind; and the build-up of waste products and medication restricts the body's metabolic processes and depletes energy. We must take positive steps toward a healthier lifestyle. We have devised a program, complete stretching, based on our yoga practice, which does not simply work on the muscles to make us more supple, it enhances concentration by attention to detail, links movement with breath, detoxifying and restoring vitality. It offers a new understanding of ourselves for it is a system that trains mind and body. Most modern therapeutic techniques have their origins in early thought systems and practices. **Complete Stretching** is based on the ancient tradition of hatha yoga, which links movement, breath, and relaxation. When we stretch into and hold a position, the body may appear static, but it is still moving, extending dynamically as the mind focuses on every limb and muscle. A good body is relaxed yet strong; well-aligned and constantly developing. Complete stretching helps achieve this.

STRETCHING FOR ALL

The desire to stretch is a natural impulse when we feel stiff. Athletes and dancers use stretching exercises as part of their warm-up. Complete stretching is not a warm-up, not a punishing physical workout, it is a basic physical need that suits people of all ages and levels of fitness — and it is rarely too late to start. Each of us is unique, so our range of flexibility is vastly different. Losing natural movement in any joint is the start of stiffness, and this increases unless we use the muscles around the joint. If we fail to release tension as it builds daily, we stiffen, and eventually lose the ability to move freely. Stretching regularly restores mobility to the joints, and eases pain. The movements in **Complete Stretching** are carefully graded, taking into account age and fitness. Accepting our limitations and working working through them carefully is an essential part of stretching. It is important, too, to set realistic, attainable goals. The daily stretch programs take about 30 minutes, and each

involves preparation, a full stretch, and then relaxation. Once you have experienced the wonderfully rejuvenating energy this simple routine provides, you will wish to make time for it as a natural tranquillizer even in the most hectic day. Complete stretching is not exercise in the conventional sense, but a means of understanding the complex workings of the body and a key to unlock the imbalances and tensions that build up during a lifetime of bad posture, poor diet, and stress. John and I practice a complete stretch program daily and have found that our physical and mental well-being has vastly improved, and that our minds and hearts have opened to a new understanding of life that we wish to share with you.

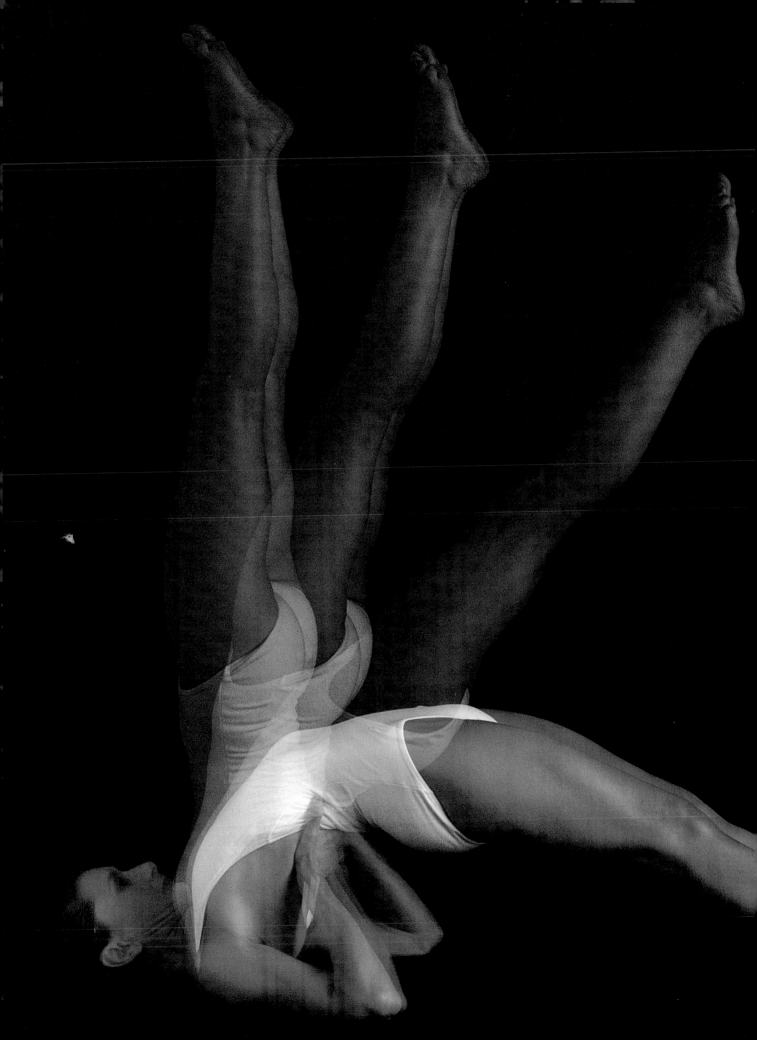

1
STRETCHING AND YOU

Stretching benefits the whole person, for not only does it tone the muscles, strengthen the spine, and increase flexibility, it benefits the mind and emotions too, soothing the nerves, relaxing the mind, and replenishing vital energy to build a foundation for total body health.

The Benefits of Stretching

MOST OF US want or need to change some aspects of our lives for the better, whether it is our health or our ability to relax. Stretching regularly can help us do this. By releasing muscular tension and aligning the body, stretching eases areas of compression that impede the workings of our organs. In doing so, it boosts all the body's systems.

BE HEALTHIER AND MORE FIT

Only a well-aligned body functions effectively and stretching helps alignment by balancing the muscles, correcting the tilt of the pelvis, and bringing the spine's curves into line. Stretching creates flexibility too, and when we open the chest, free the hips, and lift the pelvis, we liberate space in the body for the organs and their systems to function healthily, improving blood circulation and lymphatic drainage. A sedentary life, little exercise, an acidic diet that relies on stimulants, and medication affect blood circulation. This deprives the cells of nutrients that keep us energized. Stretching also counters lethargy by stimulating the flow of body fluids, keeping all the systems functioning well. As we breathe deeply, the heart and lungs receive a good supply of oxygen providing stamina; regular, detoxifying bowel movements make it more difficult for disease to set in; an excess or deficiency of hormones can be countered; and when the body is healthier, digestion is easier and the likelihood of suffering from flatulence or acidity is greatly reduced. The immune system is boosted and as general health improves, we are less prone to colds and other minor ailments.

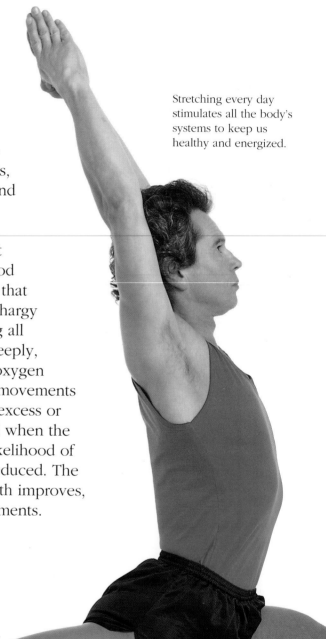

Stretching every day stimulates all the body's systems to keep us healthy and energized.

INCREASE VITALITY

When we relax really deeply, our energy levels regenerate and we start to feel vitally alive. The effects of long-term stress set up conditions within the body that lead to high blood pressure and excessive strain on the heart and other systems. Stretching helps reduce this stress by calming the nervous system and relaxing the brain. The slow, precise movements and the steady flow of breath through the body are soothing. Learning to relax counters fatigue and depression and helps us recover spent energy. Stretches that open the chest and backward bends cleanse the body, and deep breathing exercises steady the nerves. Stretches that encourage a good standing and sitting posture also help us breathe more deeply. Upside-down poses — even the semi-inverted positions — eliminate fatigue and calm the mind further, leaving the body glowing with vitality.

IMPROVE BODY SHAPE

Stretching strengthens the body and improves muscle tone while encouraging suppleness. Very few of us have a perfectly aligned or shaped body, but we can all substantially improve the definition of our muscles and transform our whole appearance by lifting the spine and relaxing the face. Stretching makes us very much aware of our bodies, and it trains the mind as well as the body, helping us to feel good about ourselves. Many of us eat too much as a direct result of emotional stress and boredom. Stretching helps counter this too, for as it actively reduces the effects of stress and enhances vitality, it gradually alters our lifestyle. Adopting a better way of life enables us to lose weight in a truly effective way, and frees us from the endless transition from one crash diet to another.

Stretching works on the mind and body, helping us become happier with our body shape.

GROW YOUNGER NOT OLDER

The way we use our bodies today will directly influence their condition later in life. Stress has an aging effect, but using the body well can release stress. All parts of the body are inter-dependent and must be balanced with each other and with the forces outside us: gravity, the environment, diet, and so on. Health is reflected in lifestyle, and if we ignore our bodies we may, even by our mid-thirties, stiffen far more than necessary. Movement lubricates the muscles, ligaments, and joints. If we become sedentary, the muscles lose tone and the muscle groups that hold us upright become unevenly matched. The joints then feel strain, lose space in which to articulate, and we start to suffer from wear and tear. At this point we become less inclined to move because it is not comfortable to do so. The joints stiffen, the muscles and ligaments, deprived of activity, lose their function, and it is difficult to move even if we wish to. This is premature aging. Stretching daily can reduce this stiffness, allowing us eventually to dance, play tennis, and enjoy our bodies well into our real old age.

Clara began yoga in her fifties. Now in her eighties, she is still teaching yoga and enjoying an active lifestyle.

KNOW YOURSELF

Becoming vital, healthier, more fit, and happy with our body shape improves self-confidence immeasurably and enables us to feel really positive about ourselves. The complete person comprises body, mind, and soul, and the needs of these elements — inner peace, health, and contentment — can be met by regular daily stretches. Stretching keeps us in touch with our strengths and weaknesses, allows us to evaluate our lives, and gives us time quietly and logically to think through problems and transform them into challenges to overcome.

ENHANCE CONCENTRATION

When we start to combine simple breathing techniques with movement, it becomes easier to focus attention, and our concentration is enhanced. Basic daily stretching strengthens the spine and diaphragm and improves the elasticity of the rib muscles, preparing us to breathe deeply without strain. Most of us find it difficult to sit or lie still and concentrate for any length of time. The uncontrolled mind moves restlessly from thought to thought and cannot remain still. By concentrating on easy breathing techniques, we can make the ever-wandering mind quiet. Mental energy that is normally dissipated becomes more focused — and this rapidly increases our clarity of mind.

Making time for a short daily fun stretch from childhood onward keeps the muscles supple and promotes mobility in the joints.

Stretching for Men and Women

IN SPITE OF the differences between the male and female bodies, we all receive the same benefits from stretching: good muscle tone, flexibility, easy movement, an aligned posture, and increased relaxation. All-round health and vitality also improve vastly.

THE MALE PHYSIQUE

Attracted to sports that develop muscles and enhance image, men often have plenty of strength at the expense of flexibility. They pay the price with stiff bodies and spine problems. Men tend to be stiff because testosterone, the male hormone, builds muscles and strength, while diminishing flexibility. Initially, it is difficult to stretch big muscles. As one of the New York Jets, John epitomized the male athlete: strong enough to abuse his body with no apparent harm. Yet muscle bulk prevented full, free motion in his joints, and he suffered lower back and knee injury. John's upper back was stiff, his hips tight from weight training, and his hamstrings, like those of most athletic men, were so short that he could not bend forward.

RELEASING THROUGH STRETCH

Starting stretching with yoga helped John loosen his hamstrings, strengthen his lower back, and improve his body awareness.

Stretching can also bring flexibility to a flat back, common in men, when the pelvis tilts back, the hamstrings are tight, and the lumbar curve is reduced, making the spine rigid and prone to injury. Stretching also increases sensitivity, encouraging a man to nurture his body not force it aggressively through rigorous training routines. This helps to enhance relationships.

Hamstrings are tight and powerful

Powerful abdominal muscles make some stretches easier

Strong shoulders and arms ease stretches that need support and strength

The spine is longer than a woman's. The sacrum is a different shape and makes a less pronounced angle as it joins the lumbar curve

Bending from the hips may be difficult

THE FEMALE PHYSIQUE

Women are attracted to stretching as a non-competitive exercise because they tend to be supple and interested in health and beauty. It is important for women to maintain a healthy spine, for the load on the spinal column may be intensified by pregnancy or carrying a child around. This also weakens the spine and leads to problems if the posture is faulty. Stretching helps keep the spine aligned and healthy. A woman's body is far more flexible than a man's, her bone structure is less dense, and her bones shorter. The hormones estrogen and progesterone help maintain flexibility. It is essential for women to relax and counter fatigue, and they gravitate readily to slow, quiet stretches that improve body shape, while encouraging relaxation and emotional strength.

STRETCH TO RE-BALANCE AND REPLENISH

Women derive energy from dynamic stretches and draw recuperation from relaxation. All the poses bring grace to the body. Some stretches help regulate the menstrual cycle, and only non-strenuous stretches should be practiced during menstruation. When there is adequate calcium in the diet, exercising before and after menopause — particularly stretches in which the muscles pull on the bones — helps retain calcium and may prevent osteoporosis, loss of bone density. Stretching can be of real benefit in easing some forms of backache that are intensified by an increased curve of the lower back. In this type of back problem, the pelvis tilts forward and, to maintain the balance, the trunk sways back. Wearing high heels and pregnancy may exacerbate this.

Abdominal muscles may not be strong, accentuated by a forward-tilting pelvis

Shoulder girdle is small, and the bones and muscles less strong than a man's

Because the hip sockets are at a different angle than a man's, the head of the thigh bone is further back and turns more easily

Lumbar and thoracic spine are more supple than a man's, making back bends easier

Elbow joints are acute and weak, affecting weight-bearing stretches

Arms provide less support than a man's

Knee joint is smaller than a man's and less prone to injury

Stretching the Spine

ANCIENT SKELETONS show that human beings have probably suffered back pain since we made the transition from walking on all fours to moving upright, for in this position the body's entire weight is carried through the spine, its discs, and the pelvis. Four-legged animals need little effort to maintain balance, whereas we need a complicated set of muscles both in front of and behind our center of gravity to stop us falling over.

THE ANATOMY OF THE SPINE

Most of us are unaware of what the backbone, or spine, does or even what it looks like. The spine is made up of a chain of 33 small bones, vertebrae, which form the skeleton's central support. Between each bone is a cushion of cartilage, or disc, prone to injury if we use our bodies badly. Protruding from the vertebrae are spikes and struts, acting as levers for the powerful muscles and fibrous ligaments that hold the spine in place yet stabilize the body as it moves. The spine is not a solid piece of bone but a column of small sections forming five curves, including the coccyx. This gives it great strength — ten times that of a straight, rigid column — and flexibility too. The spine does not move as a whole, but in segments, the vertebrae turning on and gliding over each other. This flexibility enables us to bend, twist, and hold ourselves upright, and for optimum health and mobility all the curves must be in balance. Unfortunately, this flexible column is inserted in a more rigid pelvis, and imbalances here, or weak abdominal muscles and a tight lower back, make the lower spine prone to injury. Lower back injury is a major cause of lost working days, and regularly stretching the spine helps protect it and retain flexibility.

CERVICAL CURVE *Seven small vertebrae, concave at the neck. This area allows most movement but can be restricted by imbalances in posture. All movement here should be, but rarely is, free and unimpeded*

THORACIC CURVE *Twelve intermediate vertebrae curve back at the chest. This area bends sideways and turns freely. Back bending is limited, especially in the upper part*

LUMBAR CURVE *The five largest vertebrae curve in at the back of the waist. This segment of the spine bends forward and back easily, but allows only a little twisting and side bending*

SACRUM *A large triangle of five fused segments wedged between the pelvis. Curving back, this area allows small rocking motions. The upper part articulates with the fifth lumbar vertebra. Injuries often occur here. When the pelvis is horizontal, hip and spine movements are easier*

COCCYX *An outward curve of four very small fused bones. This area affects balance*

STRETCH TO RE-BALANCE

The spine, particularly the lumbar curve, needs a wide range of movement. Changing position even for a short time releases compression on the discs. As we bend, invert, and twist, we boost strength and suppleness, cure minor spine problems, and bring a healthy supply of blood to the discs and nerves, vital as we age.

Cervical problems If the head is too far forward the neck vertebrae collapse (cervical lordosis), and eventually the ligaments and muscles weaken. Work on:
Boosting Vitality pp. 46-49
Toning the Muscles pp. 22-33
Keeping the Spine Supple pp. 54-63

Thoracic problems Stooping shoulders (exaggerated thoracic curve) cause the chest to cave in, impairing breathing. Work on:
Keeping the Spine Supple pp. 54-63

Lumbar problems A forward-tilting pelvis increases the lumbar curve (excessive lumbar lordosis). Because it is easy to move in this area, many movements are made here, weakening it. Work on:
Twisting Sideways pp. 50-53
Lengthening Forward pp. 40-45

Sacral problems A pelvis tilting forward weakens abdominals and tightens the groin. Bad posture limits hip movement. Legs uneven in length or an uneven pelvic tilt cause wear and tear. Work on:
Twisting Sideways pp. 50-53

MUSCLES AND THE SPINE

In perfect working order, muscle groups are balanced at the front, back, and side of the spine (see below), but they rarely develop evenly. Bad postural habits start early, and neither spinal deviations nor back pain are uncommon.

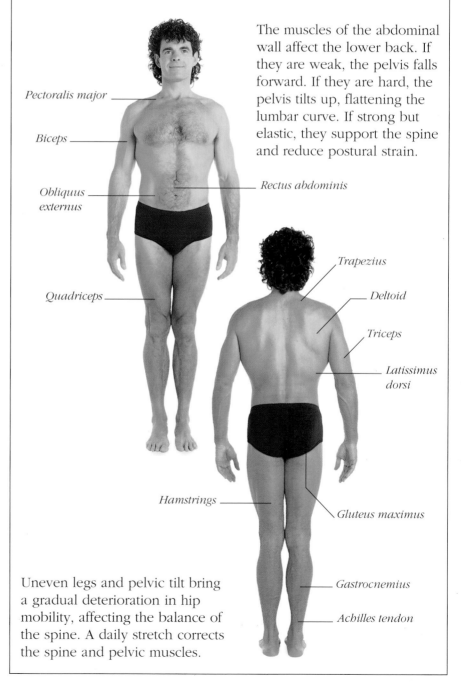

The muscles of the abdominal wall affect the lower back. If they are weak, the pelvis falls forward. If they are hard, the pelvis tilts up, flattening the lumbar curve. If strong but elastic, they support the spine and reduce postural strain.

Pectoralis major

Biceps

Obliquus externus

Rectus abdominis

Quadriceps

Trapezius

Deltoid

Triceps

Latissimus dorsi

Hamstrings

Gluteus maximus

Gastrocnemius

Achilles tendon

Uneven legs and pelvic tilt bring a gradual deterioration in hip mobility, affecting the balance of the spine. A daily stretch corrects the spine and pelvic muscles.

Preparing to Stretch

YOU CAN CHANGE the condition of your body by practicing a regular stretching program, and by using relaxation and deep breathing techniques you can alter your mental and emotional state. As you progress through the programs, you will stretch in all directions, bringing freedom to your muscles and joints and enabling you to experience a new appreciation of life. However, do allow this change to take place gradually, and let the transformation be fun and gentle: forcing your body into stretches will eventually lead to injury. First get to know your body with all its strengths and weaknesses using the simple exercises on page 19, then work to your own level as you practice stretching. To get the most out of your stretching program, follow the advice given below, which will enable you to stretch in complete safety.

SAFE STRETCHING

● If you are healthy you can stretch. Anyone is capable of the basic positions or modified stretches in this book, but if you have any doubts at all, seek medical advice before you start to practice.

● If you suffer from severe stiffness in the mornings and you are an older person, seek medical advice before starting a stretch program. Arthritis may be affecting your body.

● For yoga classes worldwide, we recommend teachers trained in the system of B.K.S. Iyengar.

● It is not advisable to start a stretch program when you are pregnant.

● Wear loose clothing. Leotards and tights are not essential for women: wear whatever is comfortable.

● Practice on a non-slip clean surface with bare feet so you can stretch out your toes for maximum contact with the floor.

● Do not stretch immediately after eating. Practicing on an empty stomach is more beneficial, for it helps cleanse the body.

● Start slowly so your body gets used to the correct movements. Even if you have been exercising for some time and your body is very supple, practice standing stretches daily for some weeks before trying anything more advanced.

● Practice the stretches in the order they are presented. Try to learn them in this sequence, rather than by randomly choosing one or two poses. The time to add new stretches is denoted in the text.

● Rest when your body is tired. At the start rest after each stretch by bending forward with arms relaxed.

Your levels of energy and stamina will increase as you start to practice regularly.

● Never force your body into a stretch; instead, relax your muscles. As you extend from your bones, your muscles will elongate, creating space in your joints and promoting freedom of movement.

● Go into each movement on an out-breath, and then breathe normally. Do not hold your breath: this only causes tension and strain. As you come out of a stretch, breathe in, breathe out, and release.

● Hold each stretch for as long as you can keep releasing your muscles comfortably. At first this will be only a few seconds. As you practice regularly, the time you can hold a stretch will gradually increase.

● Be conscious of the way your spine moves as you stretch, and feel the movement along the back of your body as well as the front.

● Practice each stretch on both sides of the body, holding the position for the same length of time on both sides. Stretch first to the right, then repeat the movement to the left. You may stretch more on your stronger side: make sure you work both sides evenly.

● Come up out of a stretch with as much care as you go into it, repeating the movements you used to go into it in reverse order. Take special care in upside-down stretches, for coming down too fast could put excessive strain on the vertebrae of the neck.

● Stretching is most effective when practiced slowly and with concentration. Do not make bouncing or jerking movements (ballistic stretching) which can overtense the muscles, leading to spasms and tearing.

HOW SUPPLE ARE YOU ?

Perhaps you are not as supple as you would like to be. Key stretches to assess your overall flexibility are shown on the left below. On the right, explanations highlight common problem areas and show how to simplify each stretch, using props such as belts, blankets, and blocks. Pioneered by world authority on yoga, B.K.S. Iyengar, props let you release into a stretch without strain. In Home Workout you will find ways to modify stretches to suit your level.

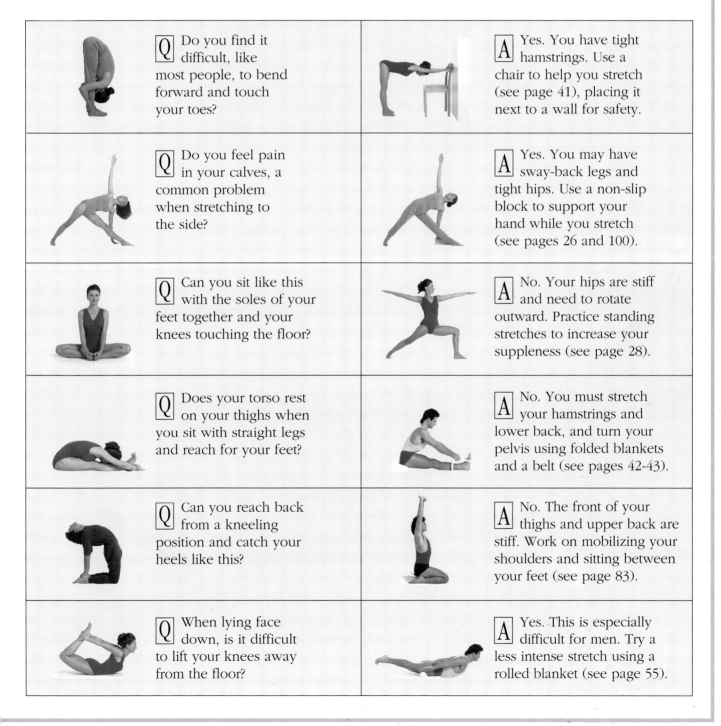

Q Do you find it difficult, like most people, to bend forward and touch your toes?

A Yes. You have tight hamstrings. Use a chair to help you stretch (see page 41), placing it next to a wall for safety.

Q Do you feel pain in your calves, a common problem when stretching to the side?

A Yes. You may have sway-back legs and tight hips. Use a non-slip block to support your hand while you stretch (see pages 26 and 100).

Q Can you sit like this with the soles of your feet together and your knees touching the floor?

A No. Your hips are stiff and need to rotate outward. Practice standing stretches to increase your suppleness (see page 28).

Q Does your torso rest on your thighs when you sit with straight legs and reach for your feet?

A No. You must stretch your hamstrings and lower back, and turn your pelvis using folded blankets and a belt (see pages 42-43).

Q Can you reach back from a kneeling position and catch your heels like this?

A No. The front of your thighs and upper back are stiff. Work on mobilizing your shoulders and sitting between your feet (see page 83).

Q When lying face down, is it difficult to lift your knees away from the floor?

A Yes. This is especially difficult for men. Try a less intense stretch using a rolled blanket (see page 55).

2

HOME
WORKOUT

This selection of stretches has been
specially chosen to loosen up and
release stiff areas of the body,
and tone and strengthen weak ones.
A graded series of daily programs
provides a framework for practice,
which will give a sense of real,
definable achievement.

Toning the Muscles

ONE OF THE FUNCTIONS of stretching muscles is to tone them and restore balance to the body, leading to greater health and fitness. Learning to lift up against gravity and stand correctly is where muscle tone begins, for whether standing or moving, the human frame must continually combat the force of gravity pulling it to the center of the earth. Muscles work basically in opposite pairs, balancing each other as the body moves, one set contracting and shortening, the opposing set releasing and lengthening. Yet because we tend to lead sedentary lives, the muscles that hold the skeleton upright are often unevenly matched: one group short and hard, the opposing group flaccid and weak. Untoned muscles do not support the skeleton well, and the joints then absorb strain. Good muscle tone transforms not just the way we stand but our entire range of movements, enabling the body to work with the least amount of strain, conserving energy. Standing stretches, the foundation of this stretch program, are highly effective in bringing change to the body.

THE BENEFITS OF STANDING STRETCHES

• *These stretches really strengthen and tone weak muscles — which produces the added advantage of correcting minor spinal deviations.*
• *The flexibility of the hip joints is improved.*
• *When the stance is correct, the center of gravity runs through the five curves of the spine.*
• *These invigorating stretches improve blood circulation, stimulate digestion, and, by using the rhythm of breathing, develop the ability to concentrate.*

STANDING UPRIGHT

The firmer you are in your feet, the easier it is to stretch your whole body. If stretching with your feet together is difficult initially, in time you will feel the benefit as it works the leg muscles more strongly and evenly. As the legs stretch, feel the spine lengthen from its base at the tailbone up the back of your body.

1 Although they create only a small base, the feet play an immensely important role in balancing the entire body. Stand with the outer edges of your feet parallel to each other, your big toes touching.

2 Extend back from the center of your arches into your heels, and extend forward into the balls of your feet to balance your weight evenly. Do not grip your toes: stretch them along the floor, keeping the weight even on the inner and outer edges of your feet.

3 Extend your legs up from the arches of your feet and stretch up through your ankles, Achilles tendons, shins, and calves. Lift your knees, and stretch from your thighs up to your hip joints.

4 Contract your anal muscles, and lift your pelvis away from your thigh bones. Move your coccyx (tailbone) forward, and lift your sacrum (the base of your spine).

5 Lengthen all the spine's curves. Lift up and separate your back ribs from your spinal column. Continue to lift up through your upper spine. Drop your shoulders, and extend your neck. Stretch the backs of your arms down into the tips of your fingers.

6 Maintain a feeling of lightness and firmness without tension as you stand, and breathe smoothly and easily. Do not hold your breath: let it flow freely and continuously, without feeling strain in your eyes, ears, or throat.

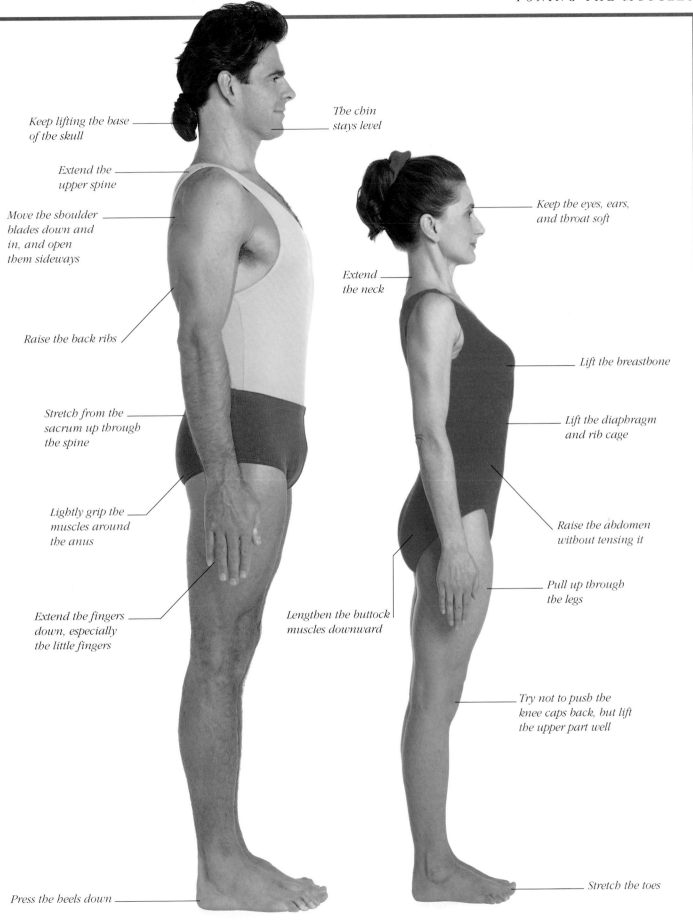

Keep lifting the base of the skull

The chin stays level

Extend the upper spine

Keep the eyes, ears, and throat soft

Move the shoulder blades down and in, and open them sideways

Extend the neck

Raise the back ribs

Lift the breastbone

Lift the diaphragm and rib cage

Stretch from the sacrum up through the spine

Lightly grip the muscles around the anus

Raise the abdomen without tensing it

Pull up through the legs

Extend the fingers down, especially the little fingers

Lengthen the buttock muscles downward

Try not to push the knee caps back, but lift the upper part well

Press the heels down

Stretch the toes

STRETCHING UP

Bring a sensation of lightness to every part of your body with this upward stretch for the whole body, practiced standing up. Feel your rib cage lift, your lungs expand, and your abdomen stretch. Raise your leg onto a ledge, but not too high, to feel a good stretch in your pelvis.

Stretch the palms and fingers

Stretch the shoulders and arms

Lift the back ribs

2 Release your hands far apart to stop the muscles in your neck from tightening. Stretch your entire body up, but do not force your arms back and collapse into the back of your waist: keep them slightly forward, and keep your spine lifted. Hold, and breathe steadily for 20-30 seconds. Bring your arms down on an out-breath.

INCREASING THE STRETCH

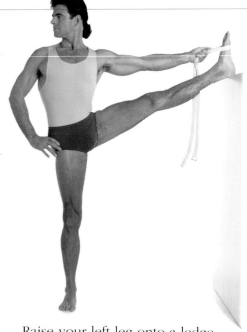

1 Stand, feet together. Stretch up. Interlock your fingers behind your head, elbows to the side. Breathe out, turn your palms up, stretch your arms, and compress the outer part of your legs.

Raise your left leg onto a ledge. Straighten your knee. Catch your foot or loop a belt firmly around it. Rotate your thigh back (do not collapse your spine or bend your knee). For a pelvic stretch, keep your right foot in line with the ledge and lift your entire spine. Breathe evenly for 20-30 seconds. Repeat on the other side.

STRETCHING UP — SITTING

Sitting up straight strengthens the lower back and tones the abdominal muscles. It is more difficult than stretching up while standing, but the effects are greater because when the hips are flexed, the work is primarily in the spine, not the legs. The muscles of the abdominal wall affect the lower back, and when they are slack, the abdominal toner (right) is beneficial, especially for women. Add this more difficult stretch to your program when you are stronger.

INCREASING THE STRETCH

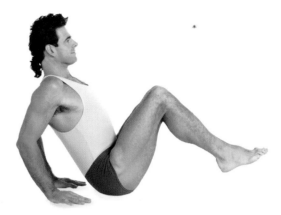

1 Use this stretch to tone your abdominal muscles, which should be strong but quite elastic (see also pages 50-53). From sitting up straight, bend your knees, lift your lower back, and stretch your legs as high as you can. Lift both your lower and upper back, and extend the back of your neck.

SITTING STRETCH

Sit forward on your buttock bones, legs stretched out, and hands near your hips. Press down onto your hands, rotate your pelvis forward, and stretch up through the length of your spine to the crown of your head. (To find out more about how the pelvis moves, see page 40.) Extend your legs into your heels, and press your thighs, knees, and shins down. Hold this stretch for 15-20 seconds.

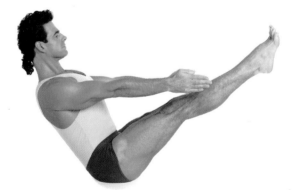

2 Stay on your buttock bones, do not collapse. Stretch your arms from your shoulders toward your legs. Extend through your legs and arches of your feet for 20-30 seconds. Breathe normally. Do not tense your abdomen. Bend your knees to release.

Extend the outer hips back

Stretch through the toes

STRETCHING SIDEWAYS

We seldom bend to the side, but this is an essential movement, for stretching the sides of the body from the hips not only tones the leg muscles and releases the lower back, it helps retain mobility as the body ages. It is also good for relieving lower back ache. When bending sideways, always stretch out from the hips, do not bend at the waist, and stretch up from the lower back to extend the whole spine.

EASING THE STRETCH

To stop the spine bending at the waist and keep the extension equal, use a block

● Put your left hand on a block (or a few blocks) in step 3, and do not go too far down at the start. This allows the back of the body to stay in one plane and lets the trunk lift more easily, enabling a better stretch in the lower back.
● Take care not to overwork the back of the neck in step 3 by throwing the head back and compressing the vertebrae of the neck. Simply lengthen this area as you look up.

1 From standing, jump your feet parallel, 3-4 ft. (about 1 m.) apart. Raise your arms to shoulder level, palms down. Lift your spine from your sacrum, and stretch your arms into your fingertips.

2 Turn your right foot in slightly, your left leg out 90°. Line up your left heel with the arch of your right foot. Pull up your legs and knees. Depress the outer part of your right foot to create resistance. Exhale. Descend, extending your spine to the left and moving your hips to the right.

3 Rest your left hand on the floor by your foot, and revolve your trunk toward the ceiling. Stretch your right arm up, and look up at your hand without throwing your head back. Hold, breathing normally, for 20-30 seconds. Come up on an in-breath. Breathe out, and repeat the stretch on the other side.

Relax the face

Maintain an equal extension on both sides of the trunk

Resist the right leg

Lengthen the back of the neck

Rotate the inner thighs outward to avoid straining the knee

Rest the hand next to the foot

EXTENDED STRETCH

When you start to practice
standing stretches, it is often
difficult to stretch very far, for
the hips need to be flexible
and the thighs must revolve
well in the hip sockets. Often
one hip is stiffer. This shows
an inbalance in the pelvis,
perhaps if one leg is slightly
shorter, or the spinal muscles
are unevenly developed. If so,
try step 3 when more flexible.

*Stretch the back
leg firmly*

Keep lifting the pelvis

*Bring the
buttock bone down*

*Balance the weight
between the feet*

EASING THE STRETCH

1 Stand upright. Jump your feet 4½ft. (over 1 m.)
apart. Stretch your arms. Turn your right foot in
slightly, left leg out 90°. Breathe out. Bend your
left knee. Bring down your left buttock so your knee
is 90°, your shin perpendicular, thigh parallel to the
floor. Move to step 2. You can also practice this step
on its own after VIGOROUS UPWARD STRETCH (pages 30-31).

● If step 1 is difficult, place a chair or other piece
of sturdy furniture in front of you, and hold onto
it for support while you practice making a right
angle with your knee and stretching your thighs.

*Lift the
inner thigh*

*Press the outer part
of the foot down*

2 Keep stretching sideways, bend your left elbow, and rest it on your thigh (or rest your hand on a block by your foot). Breathing out, turn your trunk upward. Keep your left knee back in line with your hip. Stretch your right arm over your head (palm downward). Hold for a few breaths.

Do not throw the upper body back by overarching the lower back

Keep the head in line with the tailbone

Keep the knee at a right angle

Bring the buttock bone down

3 Without dropping the right side of the trunk, stretch the left arm down, keeping it straight, and place your hand on the floor. Rest your trunk on your thigh, with your left knee against your armpit. Revolve your trunk to the ceiling. Keep your back leg firm, and extend from your right hip to your fingertips. With your head in line with your spine, turn to look up. Hold the stretch, breathing smoothly for 20-30 seconds. Then repeat the stretch on the other side.

VIGOROUS UPWARD STRETCH

As the body ages, the shoulder joints and the entire spine stiffen, but by stretching these areas regularly you can help to keep them supple and strong. This vigorous stretch benefits both the spine and shoulders, but do not raise the arms above the head if you suffer from high blood pressure.

Keep the hands apart if the shoulders are stiff

Lift the armpits

Extend up through the sides of the chest

1 Stand upright, breathe in and jump your feet 4½-5 ft. (1-1.5 m.) apart. Stretch your arms strongly away from your spine into your fingertips. Open your chest by separating your shoulder blades. Keep your feet parallel, and pull the leg muscles upward. Turn your arms back from your shoulders, palms up. Breathing out, stretch your arms over your head.

Make sure the feet are parallel to each other

EASING THE STRETCH

● When you begin to practice step 2, your back heel may lift off the floor as you try to turn your hip. To prevent knee injury, try the stretch raising this heel against a wall so your hips are fully turned. This also helps if you have lower back problems.
● If your back aches after practicing this stretch, lie flat on the floor, bend your left leg close to your trunk, and hold it around your shin bone for 30 seconds, keeping your right leg straight and breathing normally. Repeat with the other leg.

Make a right angle with the front knee

Keep the back heel pressed against a wall

Look up at the hands

3 Stretch up through your back ribs. Breathing out, bend your left knee at 90°, shin vertical, and thigh parallel with the floor. Keep a strong, straight back leg. If your upper back is flexible, take your head back, open your chest, and look up. Hold, breathing evenly, for 20-30 seconds. Breathe in, come up, and breathe out. Repeat on the other side.

Only take the head back if you are flexible

Maintain the turn of the trunk

2 Turn your right foot in 45-60°, your left foot out 90°, and turn to face left. Turn your back leg, knee, and hip, but do not raise your back heel. The heel of your front foot aligns with the arch of your back foot.

Turn the back hip to the front

Raise the knee to the ceiling

Descend in the hips

Press the back heel down

LONG BACK STRETCH

This intense stretch helps re-balance a stooped posture and releases a tight upper back. It also loosens stiff legs and hips, tones the abdominals, and is effective after doing repetitive manual chores or playing an instrument, for it stretches the inner forearm and wrist and releases the outer forearm.

Do not strain the throat

Turn the trunk to face right

1 Standing upright, stretch, then join your hands behind your back, fingers pointing down.

Draw up through the lower and upper spine

3 Turn your left foot in slightly, the right leg out 90°. Turn your trunk toward your right leg, aligning your left hip with your right hip. Your pubis, navel and breastbone face right. If the upper back is flexible, take your head back. Hold for several breaths.

Contract the outer hips and move the coccyx and sacrum forward

Turn the leg out 90°

Turn the foot in 60°

2 Exhale. Rotate your wrists toward your spine (fingers point up). Draw your hands to your shoulder blades, pressing palms together, fingers extended. Roll your shoulders back and down. Breathe in. Jump your feet 3-4 ft. (about 1 m.) apart. Lift your pelvis and spine.

EASING THE STRETCH

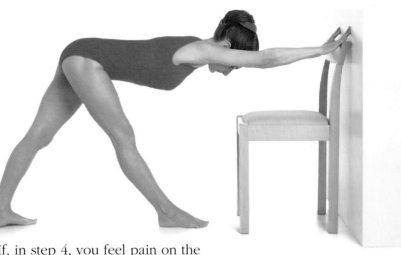

● If your shoulders or upper back are very stiff, try this alternative wrist hold for step 1.

● Both the right and left sides of the spine should stretch equally, but if the trunk has not turned fully to the right, they cannot. To remedy this, stretch out and hold onto a sturdy chair.

● If, in step 4, you feel pain on the back of the front knee, the hamstring is tight. Ease it by stretching out to a chair placed next to a wall.

Feel the hamstrings lengthening

4 Breathing out, stretch forward from your hips. Rest your trunk on your front thigh, and hold as long as is comfortable with quiet, steady breathing. To come up, breathe in and lengthen your spine, raising your head first. Breathe out and repeat the stretch on the other side.

The further down you are on the front leg, the longer you will be able to rest in the pose

Keep the weight on the back foot

Increasing Flexibility

THE BEAUTIFUL POSTURE of dancers and their range of apparently effortless movements are way beyond what we need for everyday mobility, yet we all admire them. We spend so much time sitting in the car and in front of the television or standing over machines that our flexibility is affected to a degree we little realize, and stiff hips and knees, weak spinal and abdominal muscles, a stooped back, and rounded shoulders are now the postural norm. Stretching the hips and increasing the ability of the thighs to rotate outward make the whole body more supple, improving posture and mobility.

STRETCHING THE HIPS

Lie back, and let gravity help lengthen your hamstrings in this position. An excellent stretch to practice frequently, it also releases tightness in the lower back and helps stretch out the hip muscles, increasing flexibility in these vital areas.

1 Lie on your back, legs straight, feet against a wall. Bend the right knee and catch the big toe. With your left hand on your left thigh, stretch into your heel. Exhale, straighten the right leg and arm, and stretch the leg toward your head. Hold, breathing evenly. Lower the leg on an outbreath. Repeat on the left leg.

Let the head and the back of the body stay on the floor

Keep the shoulders down

Let the leg stretch slowly and gently

Stretch the hip down

THE BENEFITS OF STRETCHING THE HIPS

- *Loosening tight ligaments and muscles around the hip joints benefits posture.*
- *Fully extending the groin area helps to achieve a more balanced and flexible spine.*
- *Opening the groin helps blood circulate more freely between the legs and torso, benefiting the supply of blood to the heart.*
- *Regaining mobility in the hip area improves all-round flexibility, especially for the lower back.*

EASING THE STRETCH

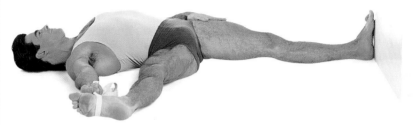

- Loop a belt around the arch of your raised foot if your hamstrings are tight and you have difficulty in catching the foot with your hand.
- If the upper back is stiff, put a folded blanket beneath your neck and head. Do not force the leg: let it stretch gently.

- If, when stretching the leg out, the inner thigh feels strained, lie parallel to a wall, the length of your leg away from it. Stretch the leg so your foot rests on the wall without having to extend down to the floor. Keep the opposite side of the trunk on the floor so the spine lengthens.

2 Raise your right leg, as in step 1 with your knee straight, then turn it out in the hip socket. Extend your leg to the right on an out-breath. The left side of your body remains on the floor. Hold for 30-60 seconds, breathing normally. Bring your right leg back to the vertical, release your foot, and repeat on the other side.

Keep this foot pressed against the wall

Straighten the knee

STRETCHING THE HIPS FURTHER

While you are sitting on the floor with one leg straight and one knee bent, resting the thigh on the floor may not cause any problems, but bringing both feet together often presents a different situation: the thighs do not descend, and it becomes difficult to remain upright. Practicing the easier stretch increases flexibility in the hips and knees, and this helps prepare for the full sitting stretch, which women generally find easier than men (see page 15).

SOOTHING HIP STRETCH

Lie on your back, feet as high as your knees on firm cushions near your buttocks. Let your thighs relax apart for five to ten minutes as you breathe evenly and quietly. When your knees have dropped lower than your feet, remove one of the cushions and relax again.

Relax the thighs toward the floor

Support the head, neck and back

Support the feet with cushions

EASING THE STRETCH

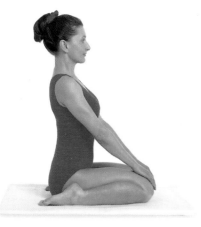

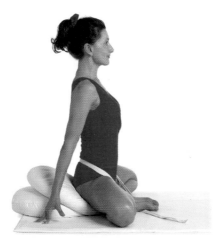

● If you find it uncomfortable to sit on the floor, or if your knees hurt when you do so, sit on a blanket, and place one or two firm cushions or folded blankets beneath your buttocks. Then ease your buttock bones back, and concentrate on lifting up from your lower back.

● Sit tall, knees together, on the heels. Spread your feet, and ease the calves to the side. Sit on the buttock bones, between the feet.

● Sit on cushions, a belt around the hips, under the pelvic bone, and around the feet. Pull the feet to the groin. Tighten the belt. Lift upward.

Relax the shoulders

INCREASING THE STRETCH

Sit on a blanket, and bring the soles of your feet together. Catch each ankle, and draw your heels in toward your pubis. Let your thighs rotate out and descend to the floor while stretching your back up. Press your fingers to the floor, and stretch up. When you feel steady and lifted from your lower back, release your hands and clasp your feet. Sit, breathing evenly, for as long as is comfortable.

Lift up and open the chest

Stretch up from the pelvis

Bring the soles of the feet together

WHOLE BODY STRETCH

A long stay in this pose, which is a good all-over body stretch, helps the body recover from fatigue. It stretches the hamstrings at the backs of the legs, extends the spinal muscles, releases tight shoulders, and, by relaxing the neck and reducing tiredness, it eases some types of headaches too. Always practice this stretch on a non-slip surface.

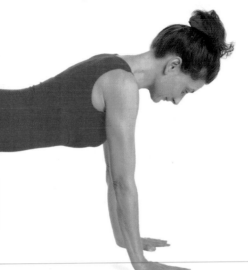

1 Kneel on all fours, hands shoulder-width apart, palms and fingers stretched. Your knees and feet should be hip-width apart, toes tucked under. Keep your hips tilted up and your lower back concave.

Move the thigh bones back _____

2 Breathe out. Lift your hips up high, straightening your knees. Stay on your toes, your heels and head up. Breathe in. Breathe out slowly and stretch your heels and head down, keeping your hips high.

Extend into the heels

Pull up the knee caps

Keep the feet far from the hands to give a good stretch on the spine

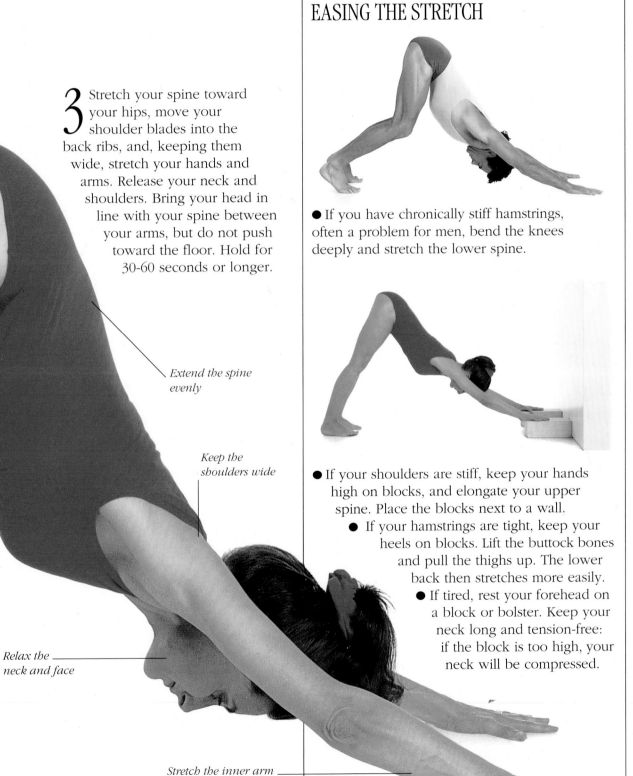

3 Stretch your spine toward your hips, move your shoulder blades into the back ribs, and, keeping them wide, stretch your hands and arms. Release your neck and shoulders. Bring your head in line with your spine between your arms, but do not push toward the floor. Hold for 30-60 seconds or longer.

Extend the spine evenly

Keep the shoulders wide

Relax the neck and face

Stretch the inner arm and all the fingers

EASING THE STRETCH

● If you have chronically stiff hamstrings, often a problem for men, bend the knees deeply and stretch the lower spine.

● If your shoulders are stiff, keep your hands high on blocks, and elongate your upper spine. Place the blocks next to a wall.
 ● If your hamstrings are tight, keep your heels on blocks. Lift the buttock bones and pull the thighs up. The lower back then stretches more easily.
 ● If tired, rest your forehead on a block or bolster. Keep your neck long and tension-free: if the block is too high, your neck will be compressed.

Lengthening Forward

OFTEN WHEN stretching forward, we bend from the waist and compress the front of the body. This can strain the ligaments, tighten the lower back, and put pressure on the discs. To stretch forward safely, improve flexibility in the hips and hamstrings, where forward motion primarily starts. As the spine bends forward, the hamstrings begin to lengthen, the hips stretch, and the pelvis turns over the head of the thigh bones. The lengthening of the lower back, letting the torso gently extend on to the thighs, is secondary.

STRETCHING FORWARD

Bending from the hips while standing lets gravity stretch the muscles of the spine. It also reduces strain on the spinal column and can be used as a relaxing pose between standing stretches.

Turn the pelvis

Keep the feet and hips in line

THE BENEFITS OF BENDING FORWARD

● *Flexibility increases in the spine, hips, and hamstrings.*
● *The abdominal muscles and organs tone up.*
● *Circulation to the kidneys increases, and the elimination of toxins is promoted.*
● *Extends the sciatic nerve, the largest nerve in the body. This keeps sciatic problems in check.*
● *Holding the stretch for several minutes relaxes the brain.*
● *Lengthening forward with arms relaxed is very restful.*

1 Stand with your feet together, legs straight. Raise your arms above your head, and stretch up. Take a breath. On the next out-breath bring your hands to your hips, maintaining the lift of your spine. Stretch forward from your hips, keeping your spine concave, your head in line. Place your hands beside your feet.

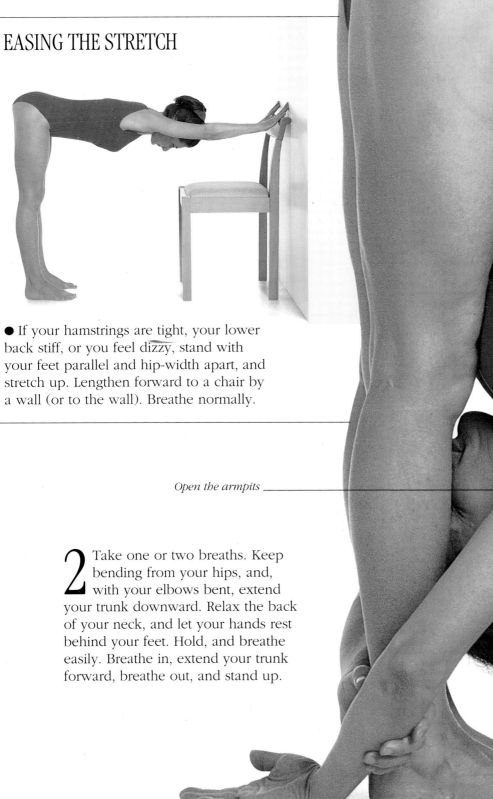

EASING THE STRETCH

● If your hamstrings are tight, your lower back stiff, or you feel dizzy, stand with your feet parallel and hip-width apart, and stretch up. Lengthen forward to a chair by a wall (or to the wall). Breathe normally.

Open the armpits

2 Take one or two breaths. Keep bending from your hips, and, with your elbows bent, extend your trunk downward. Relax the back of your neck, and let your hands rest behind your feet. Hold, and breathe easily. Breathe in, extend your trunk forward, breathe out, and stand up.

Spread the weight on the soles

RELAXING FORWARD

Sitting and bending forward so your trunk rests on your thighs reduces fatigue, calms the mind, and refreshes the brain when you feel too mentally active. As your trunk bends from your hips, your legs stretch and your spine lengthens, and while your chest rests on your thighs your breathing slows. When you are supple, hold the pose for up to five minutes.

EASING THE STRETCH

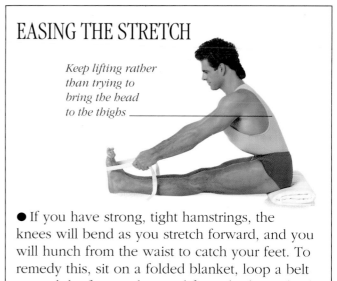

Keep lifting rather than trying to bring the head to the thighs

● If you have strong, tight hamstrings, the knees will bend as you stretch forward, and you will hunch from the waist to catch your feet. To remedy this, sit on a folded blanket, loop a belt around the feet, and extend from the lower back.
● Rest your trunk on a cushion or bolster when you bend forward to lengthen the spine.
● If you have a pelvic imbalance or a side curvature of the spine, the stretch will not be equal on both sides of your body. In this case, work with a qualified teacher.

1 Sit, legs straight, hands by hips. Press your hands down, lift the hips, and bring your weight down evenly on the buttock bones. Lift your spine, move your sacrum forward, and lift your back ribs up. Press the shoulder blades in, open the chest, and take a breath or two.

Extend gently from the base of the spine

Press the backs of the knees toward the floor

Press the outer hips back

2 Stretch forward from your hips. Catch your feet. Lift the front of your body from your pubis, extending the back of your neck. Breathe out. Draw your spine forward until your chest rests on your thighs, your head rests on your shins. Catch your wrist beyond your feet, and hold for 30-60 seconds. Breathe in and come up.

HAMSTRING STRETCH

If you have some flexibility in your hamstrings, this is a good way to extend them further. Stretching the hamstrings helps provide the suppleness you need to bend forward and backward.

1 Sit on a blanket, legs straight, hands just behind your hips, spine lifted. Bend your right knee. Bring your heel to your groin. Keep your left leg straight, back of the thigh down. Stretch your spine. Lean back slightly to lift your lower back.

EASING THE STRETCH

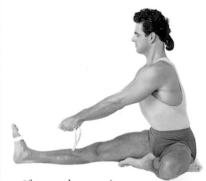

● If your hamstrings are very tight, it is impossible to catch your foot without hunching and straining your spine. Practice sitting on firmly folded blankets, a belt looped around the arch of your foot.
● To support the spine, stretch onto a bolster (see page 96).
● If you have a knee problem, do not take the knee too far back, and support it with folded blankets.

2 Move forward from your right hip, catch your left foot with your right hand, turning the right side of your trunk to face your left leg. Let your left hand join your right. Breathe in and stretch up, making your lower back concave. Relax your shoulders and neck.

3 Breathing out, extend the trunk along your left thigh, resting your abdomen, chest, and finally your head on your shin. Clasp your right wrist with your left hand. Hold as long as is comfortable, with relaxed breathing. Breathe in, and release gently. Breathe out. Repeat on the right leg.

Catch the hands beyond the feet

OPENING THE THIGHS

This stretch boosts circulation in the pelvic area, stimulates the ovaries, and regulates the menstrual cycle. It is not easy: it takes time for the insides of the thighs to extend, and the lower back and buttocks to stretch, so the pelvis can turn.

1 Sit on the floor, legs spread wide without forcing them apart, your weight distributed evenly on both buttock bones. Place your hands behind your hips for support, and stretch up through your spine.

2 Extend forward from your hips, and catch your feet. Keep your knees straight, heels extended. Moving from your hips, stretch your spine toward the floor, keeping the front of the body extended. To avoid straining your inner thighs, do not let your thighs and feet roll in.

Do not pull with the hands

Keep the shoulders relaxed

EASING THE STRETCH

● If you have to hunch over to catch your feet, practice this additional stretch, for keeping the back long is more important than catching your feet. Never force yourself down to the floor, especially if the inner knees are painful or you have to bend over to catch your feet. Sit on firmly folded blankets with a belt looped around the arch of each foot, then stretch up.

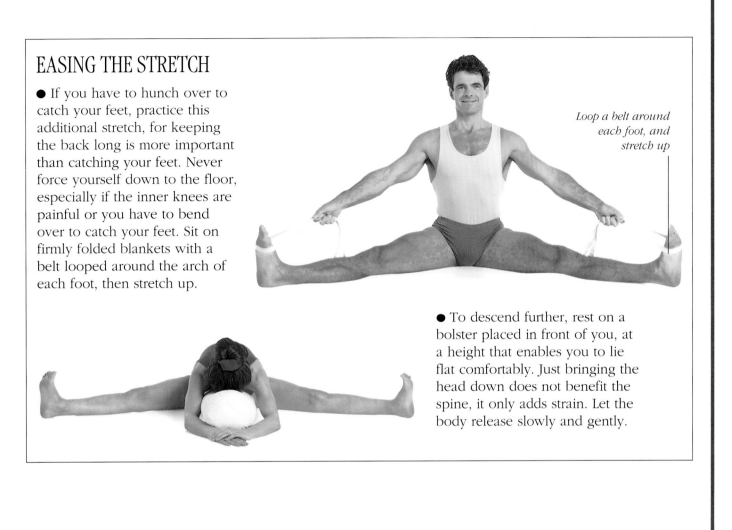

Loop a belt around each foot, and stretch up

● To descend further, rest on a bolster placed in front of you, at a height that enables you to lie flat comfortably. Just bringing the head down does not benefit the spine, it only adds strain. Let the body release slowly and gently.

Stretch further and further from the hips

3 Breathe evenly, extending from the buttocks with each out-breath. Rest the front of your body on the floor for a few seconds, breathing normally. Breathe in and come up. Breathe out and release.

Extend the heels

Boosting Vitality

INVERTED STRETCHES benefit everyone, but they are especially effective if your work is sedentary, for they relieve tightness in the shoulders and neck, boost circulation, and encourage a renewing sense of vitality. The fully inverted stretch, a classical yoga pose, evokes calmness as it stills an active brain and soothes the nerves. These stretches are particularly effective after a stressful day.

FULLY INVERTED STRETCH

Introduce this soothing but revitalizing stretch into your program quite early on. Although the completely extended stretch may take some time to achieve, its benefits make it worth all the weeks of work. If you are a beginner, overweight, or stiff in the upper back, try the less demanding stretch on page 48.

1 Center yourself with the base of your neck, shoulders and elbows on blocks or firmly folded blankets. Keep your neck curving softly, your head on the floor. Turn your palms over, push down, and lift your hips toward your head. Bend your elbows, and support your back with your hands, fingers toward the spine.

THE BENEFITS OF INVERTING THE BODY

Turning upside down reverses the pull of gravity on the body, with specific benefits:
- *Gravity holds the muscles in place. Being upright but not aligned has an adverse affect on the muscles and internal organs. Turning upside down allows gravity to pull the organs back into place and reduces strain on the muscles.*
- *Stimulating circulation improves lymph drainage. This nourishes cells in the muscles and skin and promotes waste elimination.*
- *Gravity takes blood to the brain with minimum effort, and this helps induce mental relaxation.*
- *Inverted poses allow gravity to drain the lower body, relieving tightness and fatigue in the legs and feet.*
- *As the upper spine lengthens and the rib cage opens, breathing improves.*

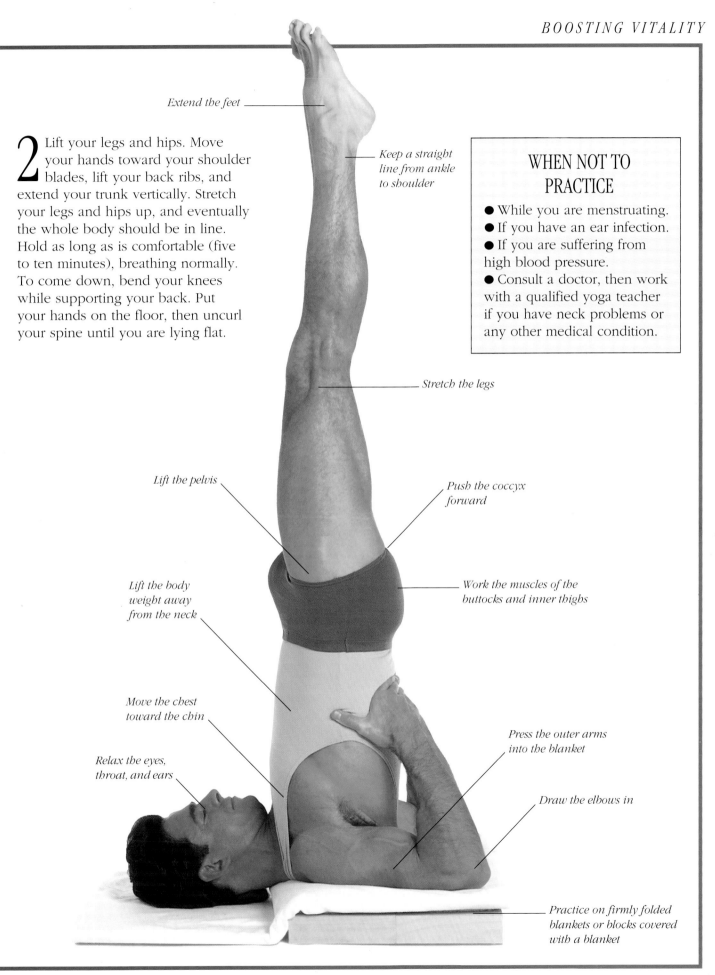

Extend the feet

2 Lift your legs and hips. Move your hands toward your shoulder blades, lift your back ribs, and extend your trunk vertically. Stretch your legs and hips up, and eventually the whole body should be in line. Hold as long as is comfortable (five to ten minutes), breathing normally. To come down, bend your knees while supporting your back. Put your hands on the floor, then uncurl your spine until you are lying flat.

Keep a straight line from ankle to shoulder

WHEN NOT TO PRACTICE

● While you are menstruating.
● If you have an ear infection.
● If you are suffering from high blood pressure.
● Consult a doctor, then work with a qualified yoga teacher if you have neck problems or any other medical condition.

Stretch the legs

Lift the pelvis

Push the coccyx forward

Lift the body weight away from the neck

Work the muscles of the buttocks and inner thighs

Move the chest toward the chin

Press the outer arms into the blanket

Relax the eyes, throat, and ears

Draw the elbows in

Practice on firmly folded blankets or blocks covered with a blanket

FULLY INVERTED STRETCH

EASING THE STRETCH

1 Sit sideways to a wall, hips as close to it as possible. Swivel around, hips still close to the wall, and lie as on page 46: the base of your neck and your elbows on the blanket, legs up the wall.

2 Bend your knees and, with an out-breath, press your soles against the wall. Lift your hips, supporting your back with your hands. Move your elbows in closer and, as you lift your spine higher, let your weight move onto your shoulders.

3 Walk your feet higher, and hold as long as you are comfortable, breathing normally. To descend, lower your hips carefully to the floor, and then rest the spine for a while.

Keep the hips lifting

Keep the elbows and the base of the neck on the blanket

● In FULLY INVERTED STRETCH (page 46), the neck bends onto the torso, and great care must be taken if the neck muscles are weak or the vertebrae protrude. To stretch safely, add blankets, so your body is lifted at least 4 in. (10 cm.) off the ground. Secure a wide belt above your elbows to keep them in line with the shoulders. This lifts the upper back and takes weight off the neck.

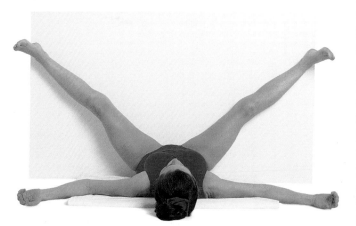

● When you are menstruating, try this even more restful variation of the inverted stretch. Lie flat on your back with your pelvis near a wall and your arms stretched out from your shoulders. Then let your legs gently relax apart.

● Do not try FULLY INVERTED STRETCH (page 46) too near the edge of the blankets: you may roll over your head as you come up.
● If you feel pressure in your ears or eyes, or the throat is constricted, try steps 1 and 2 of the easier stretch above, but with firm bolsters by the wall. Start with the hips further away from the wall as you swivel around. Relax with your hips on the bolsters (see page 97).

STRETCHING FURTHER

Once you have achieved FULLY INVERTED STRETCH, progress to bring your legs over your head so that they eventually rest on the floor. While extending the back further, this stretch is more restful. Stretch only as far as is comfortable, and keep the spine lifting upward.

1 Stay in the final position of FULLY INVERTED STRETCH (page 47). Breathe out and lower your legs over your head to the floor, knees bent to avoid strain. Lift your spine, supporting it with your hands. Extend your knees, and lift your outer hips. Hold for a few minutes, breathing normally.

2 Keep your spine lifted. Relax, breathing easily, for several minutes. If you feel secure, stretch your arms over your head. To bring your legs down, rest your palms on the floor, and uncurl your spine gently.

EASING THE STRETCH

● If your throat, face, or eyes feel strained, you have taken your feet down too soon. Stretch your legs down to a chair or some books. Relax in the position for a while. Bend the knees. Bring the legs down.

● If your hamstrings are tight, place a chair close to your shoulders. Go into FULLY INVERTED STRETCH (page 46). Breathe out, bend your knees and rest your thighs on the chair. Relax for five minutes, breathing normally.

Keep lifting the outer and inner hips

Do not let the back stoop

Stretch the legs

Keep the face relaxed

Extend the arches of the feet, keeping the heels lifted, toes on the floor

Twisting Sideways

TWISTING LATERALLY, or from side to side, is a movement alien to most of us. Yet it can relieve backache, and by relaxing the muscles and boosting blood supply to the discs and nerves it keeps the spine healthy too. To twist safely, start in the pelvis, and take the action up through all the spine's curves, for turning just from the shoulders and ribs can cause strain in the lower back. If you have a spinal distortion, work with an Iyengar yoga teacher, or consult an osteopath or chiropractor.

THE BENEFITS OF TWISTING THE SPINE

- *Neck problems often result from tightness in the shoulder girdle and the muscles around the upper spine. Twists make this area more flexible.*
- *Twists ease constipation as they squeeze the internal organs, improving digestion and stimulating sluggish bowels.*
- *Twisting alleviates tightness in the rib cage, making flexing and extending smoother.*
- *These movements relieve pressure on the vertebral discs, easing tightness in the lower back.*
- *The neck, arms, shoulders, and spine benefit, as do pelvic and hip movements.*
- *Standing twists give a good indication of how to align the spine and move it correctly.*

INCREASING THE STRETCH

Lie as in step 1 but with your left leg straight. Exhale. Take the right knee and foot left, as far from your body as you can, to rest on the floor. Hold, breathing evenly, left hand on the right knee for 30 seconds. Repeat on the left.

GENTLE TWIST

This soothing side stretch, particularly useful for relieving backache, makes a good introduction to lateral twists.

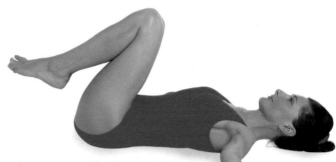

1 Lie on a blanket with your arms stretched out at shoulder level. Bend your knees up over your abdomen, keeping your spine on the floor.

2 Breathe out. Take your knees to the right, keeping the shoulder blades on the floor. Hold for one or two breaths. Breathe out, bring your legs up, and repeat on the left. Repeat several times on each side.

Keep the shoulder blades on the floor

Look up for more stretch

STANDING TWIST

Add this stretch, which is especially recommended for lower back ache, when you feel confident stretching your body sideways (pages 26-27), for elongating the lower back as you twist requires supple hamstrings and some degree of flexibility in your hips. Place a block close to your right foot in step 1 when you start to learn this stretch. This will help to keep your body lifted and light.

1 Stand with your feet 3-4 ft. (about 1 m.) apart, arms stretched, palms down. Turn the left foot in slightly, the right foot 90° to the side. Line up the right heel with the left arch.

2 Breathing out, twist from the hips, stretching your left arm over your right foot. Your right thigh moves back as the left side of your pelvis turns. Keep the distance between pelvis and ribs equal on both sides.

Turn the left side of the pelvis

Keep the head in line with the hips

Move the left shoulder blade in to open the left side of the chest

3 Stretch your left arm down to the block, your right arm up in line with your shoulders. As your arms stretch, open your chest and widen your shoulder blades. Hold, breathing regularly, for 20 seconds. Repeat on the other side.

SITTING ROTATION

Tight hamstrings may cause strain when the body moves and can be a barrier to twisting, for they tip the pelvis back, make the lower back collapse, and force the shoulders to slump forward. Those with stiff hamstrings can ease twists by stretching with a chair.

1 Sit sideways on a chair, your left hip against the back. Stretch your feet along the floor (or on a block if you cannot touch the floor). Sit up tall.

2 Breathing out, turn and hold the back of the chair. Push against the chair with your left hand, and turn the right side of your spine from your pelvis. Stretch up, shoulders dropped, and look over your shoulder for 20-30 seconds. Breathe out. Repeat on the right.

STANDING CHAIR TWIST

Releasing tension on the spinal muscles, this stretch really benefits those with backache. Choose a chair or similar piece of furniture to stretch with, making sure that it is sturdy and not too high for your body. If the seat of the chair is too low, raise the height with blocks.

1 Stand facing the chair, and put your left foot up on the seat. Keep your left hip down. Place your hands on your hips. Stretch up from your coccyx.

2 Bring your right arm against your outer left thigh. Breathing out, turn your lower back as much as you can, lifting your rib cage and stretching your upper spine. Keep your neck long. Hold for 30 seconds. Stretch up on each in-breath; turn on each out-breath.

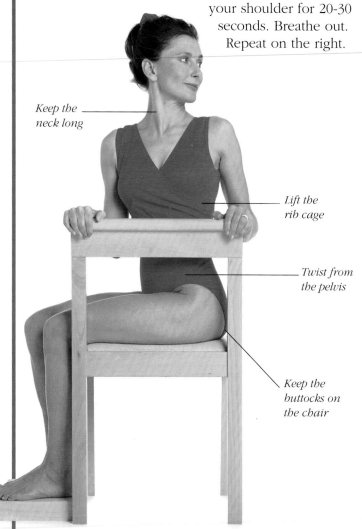

Keep the neck long

Lift the rib cage

Twist from the pelvis

Keep the buttocks on the chair

Extend the neck

TWISTING THE SPINE

Sitting on the floor to twist sideways is more of a challenge than stretching while standing, but the effects are more intense and the benefits greater. Practicing this stretch several times on each side increases your ability to rotate laterally. This helps reduce fat around the waist and speeds up the elimination of waste from the colon. If you are overweight, do not bring your foot in so close, lean further back on your hands, and emphasize the lift in the lower back as you twist.

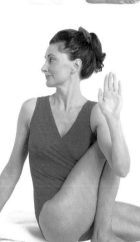

1 Sit up on folded blankets. Bend your right knee. Pull your heel to your buttock. Lean back on both hands. Lift your back from the right hand, take your left arm outside the right thigh. Exhaling, turn right, from your lower back.

2 Bring the left shoulder against the outer knee, and bend your elbow. Using your bent leg for leverage, really twist while lifting, breathing normally. Look over your shoulder for 15-30 seconds. Repeat on the other side.

Take care not to throw the head back

Turn the shoulders, ribs, and abdomen on each out-breath, and stretch up as you twist

INCREASING THE STRETCH

From step 3 extend your left arm. Turn it until your palm faces up. Breathing out, bend your arm back around your shin. Stretch your right arm, and catch your left hand or wrist. Keep the entwined side of the spine concave. Press your right foot down, move your right hip back, and turn. Repeat on the other side.

Press the foot down firmly

Extend the left leg

Keeping the Spine Supple

BACK BENDS ARE REJUVENATING, awakening vitality and creative energy, yet we rarely do them. In many activities, from standing to sitting, we collapse our spines with head and shoulders bent forward. We need to educate the body to stretch back. Backward bends form two groups: gentle strengtheners, and intense stretches needing good muscle tone and flexibility. Do not bend back if you are pregnant or menstruating, have high blood pressure or disc injuries.

> ### THE BENEFITS OF BACK BENDS
>
> ● *They encourage youthfulness by keeping the spine supple.*
> ● *Correct back bends increase strength, helping cure aches.*
> ● *Back bends release energy.*

UNDERSTANDING BACK BENDING

Whether stiff or supple, bending forward and back is easier where there is least resistance (the back of the waist and neck). Eventually this may cause injury or deterioration of the discs. When bending back correctly, the spine stretches as a single unit, its curves lengthening into a beautiful continuous arch, spreading the load evenly over all vertebrae. Not a bend in the back of the waist, this is an upper back and hip action, allowing the lower back to stretch gently.

Lengthen the neck vertebrae by lifting from the base of the skull

Release the shoulder blades away from the neck

Stretch the long upper curve back

Lengthen the lumbar

Rotate the pelvis back

Open the groin

Flex the feet

Relax the face, eyes, and throat, and breathe deeply

Extend the heels

The feet, legs, and thighs are the foundation of a good backward stretch

Stretch the buttocks away from the back of the waist

BASIC BACK STRENGTHENER

Warm up the spine with two or three of the strengthening stretches that follow. The first stretch strengthens the spinal muscles and hamstrings to keep the spine well supported in all back bends. It also helps ease some kinds of lower back ache. Do not overarch in the middle of the back: stretch up evenly. If your lower back is stiff and it is difficult to lift the legs, try the easier stretch.

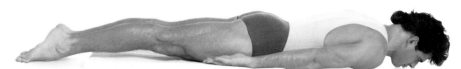

1 Lie face down, hips and pelvis supported by a blanket, arms by your sides, palms up. Stretch each leg back, and slightly rotate the front thighs inward. With feet and legs together, press your thighs, pubis, and tops of your feet down firmly, and draw your knees up. Lightly contract your buttocks.

2 Breathe in slowly. Breathing out, raise your legs and stretch your spine, bringing your head and shoulders in line with your feet. Stretch your arms back from your shoulders toward your fingertips. Hold, breathing normally. Breathing out, lower yourself to the floor and repeat two or three times.

Extend the heels

Elongate the back of the neck

Work the triceps

Stretch into the fingertips

EASING THE STRETCH

1 Roll a thick towel to about 5 in. (12 cm.) in diameter. Lie face down on a blanket, and place the towel beneath your thighs. Extend your legs one by one, and stretch your arms back, palms facing the ceiling.

2 Breathe in. Breathing out, raise your head and shoulders, and lift your thighs up. Stretch back from your shoulders into your fingertips. Hold for several breaths. Lower yourself on an out-breath.

BACK LIFT

To many of us, back bending seems impossible: we think of it as a movement made by dancers or gymnasts, and so we avoid it mentally and physically. This stretch prepares you for more intense stretches as your feet, legs, and arms support your spine, letting it gently arch back.

Lengthen forward from the upper back

1 Lie on your front. Place your hands, palms down and pointing forward, fingers spread, by the side of your chest. Stretch your legs away from your buttocks, about 1 ft. (30 cm.) apart.

2 Tighten your buttock muscles. Breathing out, push your hands and the tops of your feet down, straighten your arms, and lift your trunk and legs. Curve your spine back, and move your pelvis down. Keep your neck long. Hold for a few seconds, breathing normally. Exhale, and bend your arms to descend.

Take the weight on the tops of the feet and the hands

Push against the floor to increase the intensity of the stretch in the upper back

56

FULL BACK STRENGTHENER

Use this strong stretch to prepare for the more intense stretches that follow. Breathe easily as you stretch: it is all too easy to hold the breath. This stretch brings flexibility to the upper back, making it easier to push away from the floor in INTENSE SPINE STRETCH (pages 62-63).

EASING THE STRETCH

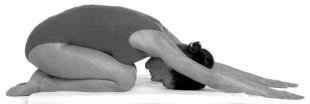

● Rest lying on the floor for a while when you come out of the stretch. Then come up onto your knees, and stretch back from your hips, resting your buttocks on your heels and stretching your arms out in front of you. This helps to relax your spine.

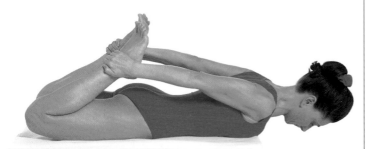

1 Lie on a folded blanket to protect your pelvic bones. Extend each leg. Catch your ankles, knees hip-width apart. Press your thighs and front of pelvis down, reducing the lower back's curve. Inhale.

2 Exhale completely. Lift your knees. Pull both legs up evenly. Stretch your shoulders back. Move your upper spine in. Draw your shins up. Hold, breathing normally, for 20 seconds. If your upper back is flexible, lift your head. Lower yourself, letting each leg go.

Let the legs stretch the arms, and the arms lift the legs

Rest on the abdomen, and breathe easily

LOWER BACK AND THIGH STRETCH

Ease into the more intense stretches that follow with some simple stretches to extend the upper spine and rotate the pelvis back. This prevents the stretch from being forced into the back of the waist. The first exercise opens the groin and stretches the quadriceps muscles at the front of the thighs.

INCREASING THE STRETCH

To stretch your groin and thigh further, after step 2 take the back foot with both hands, and bring the heel near your buttock as you lift and extend the front thigh for ten seconds. Repeat on the other leg.

1 Kneel, bend one leg, and place this foot in front of your other knee. Steady yourself by resting your hands on your front knee. Position your front foot in the mid line of your body, your shin vertical, and your trunk lifted.

2 Hands on hips, lift the front of the pelvis up and back. Stretch the back thigh forward. Repeat. Hold for 10-15 seconds, breathing freely. Repeat twice on each side.

Keep the body upright

Lift the pelvis

Drop the thigh toward the floor

STRETCHING THE PELVIS

These two stretches help the spine make its vital backward movement as a preparation for more intense stretches. It is important for those with an increased lumbar curve (see page 17) to stretch the sacrum and increase the backward stretch on the thoracic curve. This makes it easier to bend backward, relieving strain on the lumbar spine.

Stretch out horizontally on a low table, cushioning your shoulders with a folded blanket. Stretch the shoulder blades toward the back of your waist; your buttocks and legs toward your heels. Stretch your arms one by one over your head, extending them from your shoulders. Hold for up to five minutes, breathing normally. To release, bring your arms to your side before lifting your head.

EASING THE STRETCH

● Keeping your pelvis on the table, stretch back and let the shoulders rest comfortably on folded blankets or cushions, adjusted to suit your height.

Stretch the lower back, buttocks, and legs toward your heels, and breathe normally. Hold for up to five minutes. Bending the knees, slide the hips down to descend.

Open the chest

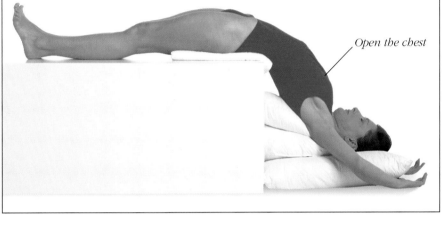

To work the pelvis, extend the inner legs

Do not tense the abdomen

Tuck in the shoulder blades

Keep the legs stretched

POWERFUL BACK STRETCH

This powerful backward stretch not only tones the entire spine while increasing flexibility in the upper back, it opens the chest and helps expand the ribs, so you will find it easier to breathe more deeply and freely. Use it to prepare your body for INTENSE SPINE STRETCH (pages 62-63).

EASING THE STRETCH

● If your throat feels strained when your head drops back, keep the back of your head lifted.
● If your feet seem far off when curving back, or if you cannot catch your heels without collapsing the buttocks back, stretch back onto two non-slip blocks by your calves, knees apart. Do not take your head back.

Stretch back onto two blocks

Keep the head in line with the spine

Lift the back ribs

1 Kneel with your thighs vertical, knees, lower legs, and feet in line with each other, checking that the base of your position is even and that one knee is not in front of the other. Stretch your arms above your head, lifting your back ribs and upper spine.

Keep the thighs vertical

2 Drop your arms and bring your hands to your hips while maintaining the lift in your back and feeling the top of the chest opening. This ensures a correct back bend. Start to curve back from the upper spine, letting your neck elongate gently.

*Relax the
face*

Open the chest

Lift the
upper spine

Bring the pelvis
forward

Lift the thighs

Press the feet
down firmly

3 Reach back and
catch your feet, far
down on them if you
are flexible. Move your
pelvis forward until your
hips are in line with your
knees. Lift, do not push,
from your thighs, and
open your groin. Drop
your head back without
straining your throat.
Hold for 20-30 seconds,
breathing evenly. Bring
your head up, and let
each hand go. Relax
back on your heels.
Repeat two or
three times.

INTENSE SPINE STRETCH

This stretch releases energy in all the body's cells and organs. Try it once you have gained strength and flexibility from basic stretches and after warming up (see pages 58-59). Then balance your body with twists (pages 50-53) and front bends (pages 40-45) before relaxing.

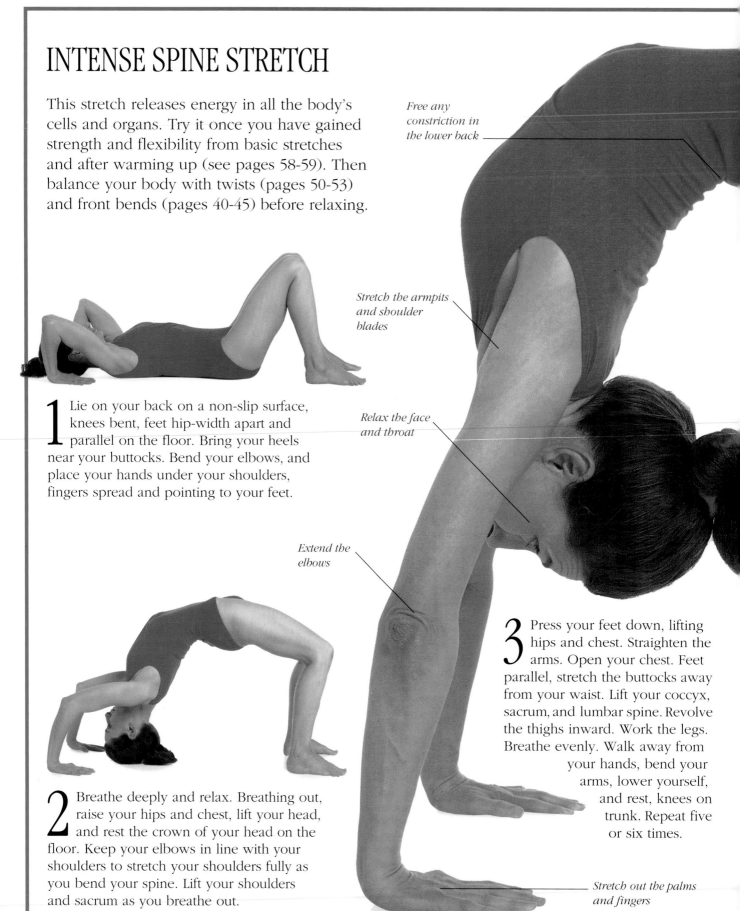

Free any constriction in the lower back

Stretch the armpits and shoulder blades

Relax the face and throat

Extend the elbows

Stretch out the palms and fingers

1 Lie on your back on a non-slip surface, knees bent, feet hip-width apart and parallel on the floor. Bring your heels near your buttocks. Bend your elbows, and place your hands under your shoulders, fingers spread and pointing to your feet.

2 Breathe deeply and relax. Breathing out, raise your hips and chest, lift your head, and rest the crown of your head on the floor. Keep your elbows in line with your shoulders to stretch your shoulders fully as you bend your spine. Lift your shoulders and sacrum as you breathe out.

3 Press your feet down, lifting hips and chest. Straighten the arms. Open your chest. Feet parallel, stretch the buttocks away from your waist. Lift your coccyx, sacrum, and lumbar spine. Revolve the thighs inward. Work the legs. Breathe evenly. Walk away from your hands, bend your arms, lower yourself, and rest, knees on trunk. Repeat five or six times.

Stretch the groin area

Keep the arms firm, and stretch up through the armpits

Lengthen the buttocks away from the waist

Revolve the thighs inward

Press the inner heels down

INCREASING THE STRETCH

When you are more flexible, raise your heels. Walk in, keeping your pelvis lifted, arms straight. Stretch your upper back, take your heels down, compress your anal muscles, and curve the whole spine.

EASING THE STRETCH

● If your shoulders are tight, put your hands on blocks by a wall, a belt around your elbows.
● Work both sides of the body evenly. Keep the feet in line: do not turn one out as you lift. Ask a friend to check that your hips lift evenly. You will gradually learn to feel and adjust weak areas.
● Neck compression causes dizziness or nausea, so curve the upper back and extend the neck.
● Men tend to have wide shoulders and if their muscles are well-developed should practice with hands and feet wider apart.

Soothing the Nerves

UNWINDING BY WATCHING television, reading, or listening to music can be refreshing, but it is only by relaxing deeply that we can experience complete physical, mental, and emotional rest. The benefits of such deep relaxation are considerable, even when it is practiced for only a short time each day. Tension and stress cause chemical changes in the muscles which lead to aches and pains, and when we feel tired, tense, and strained, everything seems to go wrong, and mental and emotional problems are more likely. Complete relaxation releases tension in the muscles. When practiced as part of a total stretch program, it also helps ease long-standing tension in the muscles that can pull the body out of alignment. The emotions and the body are inseparable: every emotion we feel is recorded in our bodies, and deep relaxation can counteract emotional disturbances. As we let go of tension in the solar plexus, suppressed feelings surface, and by getting in touch with our deeper feelings, we learn to find new peace within.

Breathing deeply also enhances relaxation, concentrating the mind as we follow the rhythm of breath. Practiced in the morning, deep breathing provides energy to sustain body and mind throughout the day.

When combined with relaxation in the evening, it restores a feeling of order and quiet, creating a natural break from the pressures of the day.

A short period of breathing should be included in a stretch program as a natural progression into deeper concentration. When we stretch, the spine develops in strength, and we automatically start to regulate the rhythm of our breathing. As the stretches become harder, we become stronger and increase the elasticity of our rib muscles and diaphragm. This is crucial if we wish to increase vitality and learn how to breathe without strain.

THE BENEFITS OF RELAXING THE BODY

● *Relaxing and enjoying a period of complete tranquillity replenishes essential levels of energy and improves the quality of life.*

● *Relaxation boosts the body's circulation and regulates blood pressure.*

● *Relaxing deeply encourages beneficial changes in both body and mind, and these help to restore good health.*

● *Physical and mental stamina develops in a new and enriching way.*

● *Deep relaxation stimulates the right side of the brain, which helps us to be constructive and creative, qualities that are essential for successful living and fulfilling relationships.*

RELAXING DEEPLY

It can be difficult to let go of tension, but the more time you allow for relaxation, the easier it is. Before starting to relax, remove glasses or contact lenses and put on loose, warm clothes, especially after stretching. Find a quiet place, and allow five minutes after stretching, or 15 minutes if just relaxing. Once a week relax for 30 minutes, especially if ill or under stress. Do not relax in the sun: this depletes vital energy.

1 Lie on a blanket. If cold, cover yourself with a blanket. Keep your body even: if it is tilted, nervous irritation may stop you relaxing. Using your hands, stretch your buttocks toward the heels. Let your waist drop, your pelvis relax.

2 Lengthen your spine up to the top of the head, releasing the curve at the back of the neck. If uncomfortable, place a small cushion beneath your neck and head. Let the chin come down slightly. Keep your throat and jaw relaxed.

3 Extend the backs of your upper arms toward your elbows. Let your arms fall away from your body, palms up. Slightly lift your rib cage. Move the shoulder blades down. Drop the tops of the shoulders.

4 Softly lower your eyelids. Breathe out, letting your feet and legs relax and the whole body release to the floor. Keep breathing gently as your muscles gradually soften and your brain becomes quiet.

5 Relax your face and feel your skin soften as you do so. At first your eyelids may flicker, showing that the brain is still active. To calm your face and brain, elongate the back of your neck. Look down.

6 Breathe through your nostrils slowly, mouth closed, with a gently controlled rhythm. To relax more, lengthen each exhalation a little. Enjoy the sensation of deep mental peace — the key to happiness.

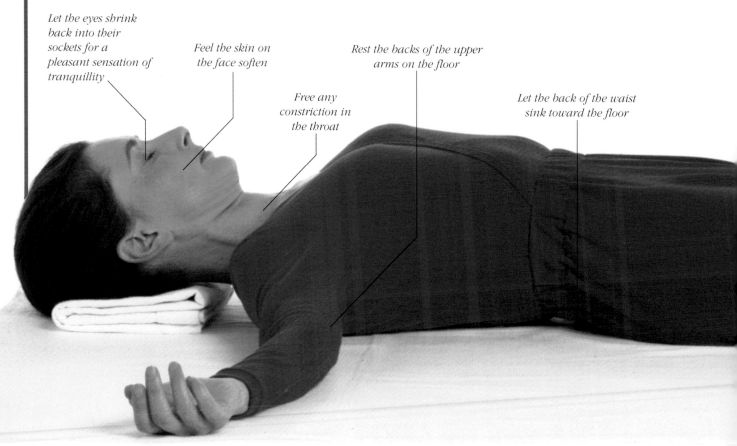

Let the eyes shrink back into their sockets for a pleasant sensation of tranquillity

Feel the skin on the face soften

Free any constriction in the throat

Rest the backs of the upper arms on the floor

Let the back of the waist sink toward the floor

EASING INTO RELAXATION

● If you feel uncomfortable
lying on your back, kneel with
a cushion between your heels
and buttocks. Stretch out over
some cushions. Let your whole
body relax, making sure your
buttocks stay on your heels.

● If you suffer from excessive
lumbar lordosis, or a sway back
that arches greatly when you
lie down, place a rolled blanket
under the backs of your knees
to ease the arch and help
your spine relax. Your
head and neck may still
need a support.

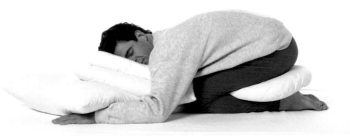

● If you have breathing problems,
support the length of your spine
by placing a folded blanket, firm
cushions, or bolster beneath it.
It is important not to let your
chest cave in. You can learn
to relax even more deeply
by covering your eyes.

*Release and relax
the legs*

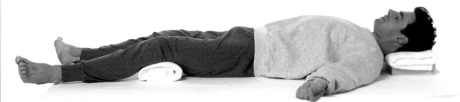

Breathing for Vitality

WE ALL ENJOY breathing deeply when we walk in the fresh air, but breathing with our minds focused is much more than this. As we breathe deeply and concentrate on doing so, we absorb from each breath energy that generates revitalizing energy within. Breathing is best practiced in an airy room on an empty stomach in the morning or evening, after relaxing fully if nervous, irritable, or exhausted. Anyone in reasonable health can try exercises with a brief holding of breath. People with high blood pressure, heart problems, or other conditions should find a qualified teacher.

THE BENEFITS OF DEEP BREATHING

- *Nourishes tissues, nerves, glands, and organs.*
- *A good supply of oxygen keeps the bones, teeth, and hair in good condition.*
- *By detoxifying the blood of excess uric acid, deep breathing improves the metabolism.*
- *By calming the nerves and regenerating vital energy, practicing deep breathing helps to regulate the appetite.*
- *Practicing basic daily stretches before starting breathing exercises strengthens and increases the flexibility of the spine and improves the elasticity of the rib muscles and diaphragm. This starts to regulate the rhythm of breathing.*

BREATHING LYING DOWN

Try lengthening your breath and breathing through both nostrils for several weeks. When your mind experiences the quietness of deep relaxation without distraction, you will find yourself practicing naturally.

Lie on a blanket, spine supported by firm bolsters. If your head drops back, support neck and head with a cushion. Relax totally. Let your breath find a smooth rhythm as the rib cage evenly rises and falls. Focus on the slow, deepening breath for five to ten minutes. Remove the spine's support, and relax on the floor. Bend your knees, turn onto one side, and stand up.

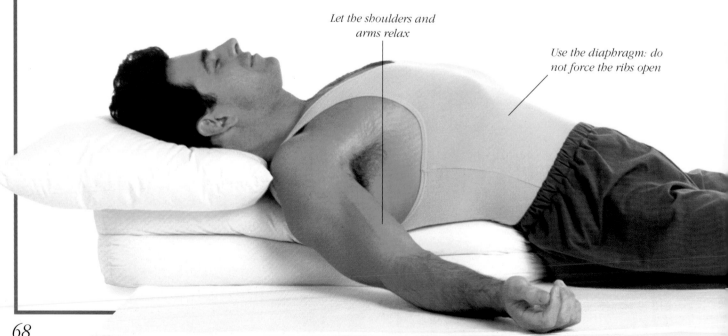

Let the shoulders and arms relax

Use the diaphragm: do not force the ribs open

DEEPENING THE BREATH

Sit with crossed legs, spine erect, or try another sitting pose (right). Stretch your spine, open your chest, lower your head and close your eyes. Breathe normally, gradually lengthening the breath without strain. First practice inhaling deeply and exhaling normally, then inhale normally and exhale deeply. If you are weak, have low blood pressure, or cannot sit, lie down.

1 Exhale. Inhale deeply through your nostrils. Let your rib cage lift and expand. Do not force the breath: inhale slowly and lengthen it without straining.

2 As you inhale, draw in your abdomen and stretch up through your spine. Your rib cage will expand sideways as the diaphragm descends. Keep your spine long, move your shoulder blades down, and keep your neck and throat soft. Maintain the lift in your rib cage.

3 Exhale slowly, controlling the outward flow of breath. Do not let the chest or spine collapse. Breathe normally. Repeat the deep breath a few times, breathing normally in between. Build up to five to ten minutes of deep breathing. Then lie down to relax.

EASY BREATHING

● If you have knee problems, sit on a hard-backed chair. Keep your thighs supported, and put your feet on a block if they do not reach the floor. Do not collapse against the chair: lift your spine. Relax the shoulders and open the chest.
● For an alternative sitting pose, sit on the floor between your feet (see page 36), and place cushions beneath your buttocks for comfort. Keeping your back upright and your shoulders relaxed, distribute your weight evenly on both buttocks. Lift your pelvis, and rest your hands in your lap. Lift up through the length of the spine, extend the back of your neck, relax your throat, and close your eyes.

*Let the legs and lower body
sink into the floor*

Basic Stretch Program

THIS DAILY GUIDE for your first ten weeks of stretching tones the whole body, whatever your age or degree of stiffness. Don't try all the stretches in the first weeks: learn them gradually. By week ten you may be doing the whole program in 30 minutes, although progress varies for each person. If you are ill or disabled, see a doctor before starting.

PREPARATION

Up to 5 minutes

Start slowly with easy, relaxed breathing. For instructions to a pose, see the pages shown. Practice all stretches here from week one.

1 STANDING UPRIGHT
See pages 22-23.
Hold for 60 seconds.

PRACTICE

15 minutes

Practice for a total of 15 minutes, adding poses week by week. If you wish, choose a simpler version from Easing the stretch in the instructions. Hold the stretches for an equal amount of time on each side of your body. To rest between standing poses, stretch forward from standing with arms relaxed.

1 EXTENDED STRETCH
See pages 28-29.
From week 1.

2 VIGOROUS UPWARD STRETCH
See pages 30-31.
From week 1.

6 STANDING TWIST
See page 51.
From week 5.

RELAXATION

10 minutes

It is important to relax after stretching. Spend some time relaxing in these recovery poses.

1 FULLY INVERTED STRETCH
See pages 46-47.
Hold for 3 minutes.
From week 3.

2 STRETCHING FURTHER *See page 49. Hold for 2 minutes.*
From week 3.

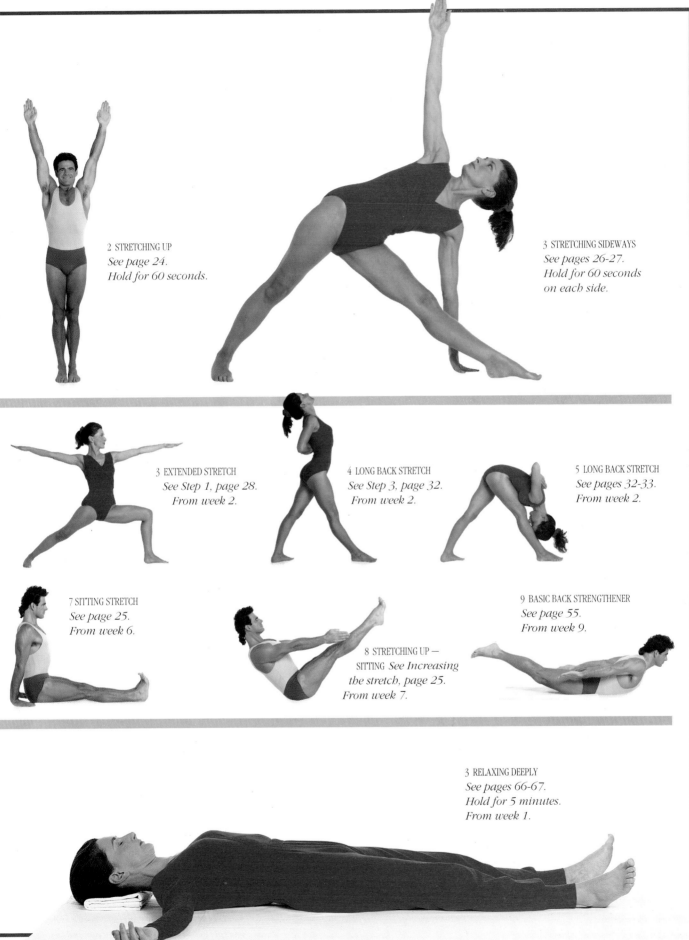

2 STRETCHING UP
See page 24.
Hold for 60 seconds.

3 STRETCHING SIDEWAYS
See pages 26-27.
Hold for 60 seconds
on each side.

3 EXTENDED STRETCH
See Step 1, page 28.
From week 2.

4 LONG BACK STRETCH
See Step 3, page 32.
From week 2.

5 LONG BACK STRETCH
See pages 32-33.
From week 2.

7 SITTING STRETCH
See page 25.
From week 6.

8 STRETCHING UP —
SITTING *See Increasing*
the stretch, page 25.
From week 7.

9 BASIC BACK STRENGTHENER
See page 55.
From week 9.

3 RELAXING DEEPLY
See pages 66-67.
Hold for 5 minutes.
From week 1.

Progressive Stretch Program

WHEN YOU FEEL COMFORTABLE with the basic daily stretch program, progress to this more advanced sequence, which takes you from weeks ten to twenty of stretching. The timings for each stretch are approximate: move into each pose carefully, without rushing. For more help, turn to Easing the stretch in the instructions to the stretches.

PREPARATION

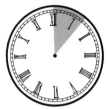

7 minutes

Start the sequence of stretches by gently warming up. Where necessary, use props such as belts, blocks, or folded blankets to help you stretch.

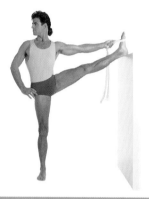

1 STRETCHING UP
See Increasing the stretch, page 24. Hold for 60 seconds on each side.

PRACTICE

Up to 10 minutes

Now focus on more vigorous stretches, extending carefully into each one. In addition, take some time once or twice a week to incorporate into your practice all the stretches from the basic program that are not shown here.

1 WHOLE BODY STRETCH
See pages 38-39. Hold for 60 seconds.

RELAXATION

13 minutes

Try not to skip on your relaxation time, but if you have less time, practice just one of these recovery stretches (preferably the first), then relax.

1 GENTLE TWIST
See page 50. Hold for 30 seconds on each side.

2 FULLY INVERTED STRETCH
See pages 46-47. Hold for 5 minutes.

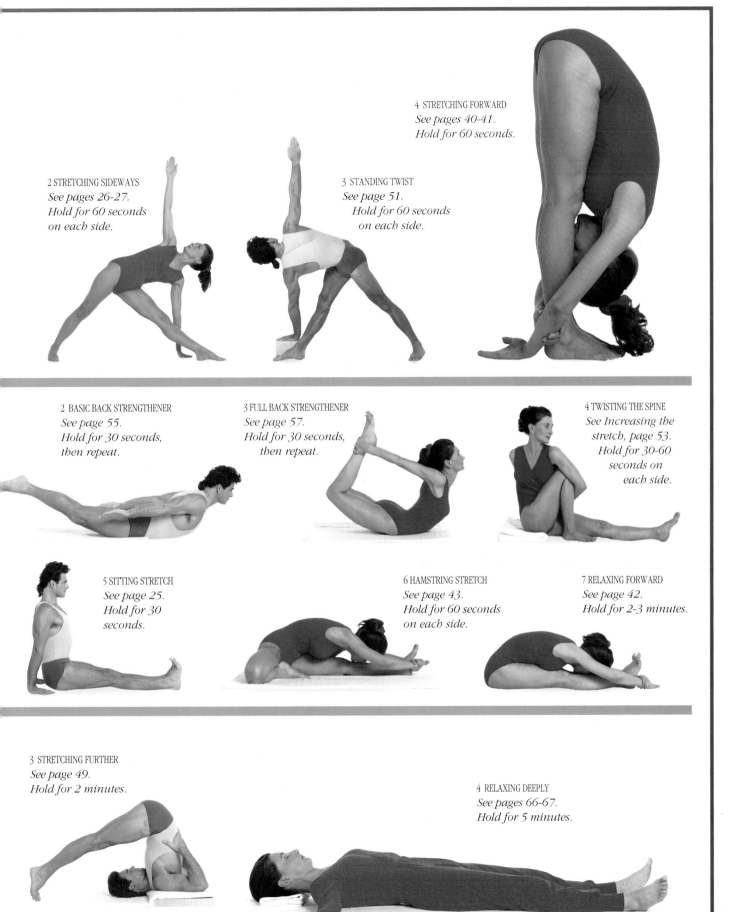

4 STRETCHING FORWARD
See pages 40-41.
Hold for 60 seconds.

2 STRETCHING SIDEWAYS
See pages 26-27.
Hold for 60 seconds
on each side.

3 STANDING TWIST
See page 51.
Hold for 60 seconds
on each side.

2 BASIC BACK STRENGTHENER
See page 55.
Hold for 30 seconds,
then repeat.

3 FULL BACK STRENGTHENER
See page 57.
Hold for 30 seconds,
then repeat.

4 TWISTING THE SPINE
See Increasing the
stretch, page 53.
Hold for 30-60
seconds on
each side.

5 SITTING STRETCH
See page 25.
Hold for 30
seconds.

6 HAMSTRING STRETCH
See page 43.
Hold for 60 seconds
on each side.

7 RELAXING FORWARD
See page 42.
Hold for 2-3 minutes.

3 STRETCHING FURTHER
See page 49.
Hold for 2 minutes.

4 RELAXING DEEPLY
See pages 66-67.
Hold for 5 minutes.

Advanced Stretch Program

THIS MORE INTENSE program will guide you through weeks twenty to thirty of your stretching practice, but do keep practicing both the basic and progressive programs twice a week too. Add these new stretches week by week. Do not rush, and remember that it may take more than thirty weeks to master INTENSE SPINE STRETCH and OPENING THE THIGHS.

PREPARATION

About 5 minutes

If you have less than 30 minutes to practice, follow the preparatory stretches with both LOWER BACK AND THIGH STRETCHES and POWERFUL BACK STRETCH, then finish the session with the relaxation stretches.

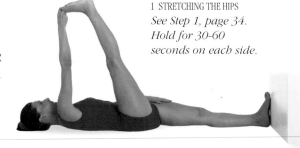

1 STRETCHING THE HIPS
See Step 1, page 34.
Hold for 30-60
seconds on each side.

PRACTICE

15 minutes

Do not feel you have to practice all these stretches at the start. As you progress in your stretching, add another new exercise until you can do all six in the 15 minutes allocated.

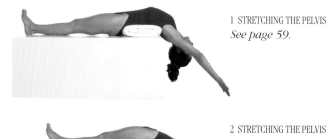

1 STRETCHING THE PELVIS
See page 59.

2 STRETCHING THE PELVIS
See Easing the stretch,
page 59.

RELAXATION

10-15 minutes

Now devote some time to recovery stretches before relaxing deeply in the final pose.

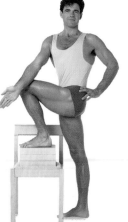

1 STANDING CHAIR TWIST
See page 52.
Hold for 30 seconds
on each side.

2 RELAXING FORWARD
See page 42.
Hold for 2 minutes.

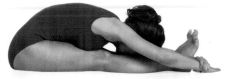

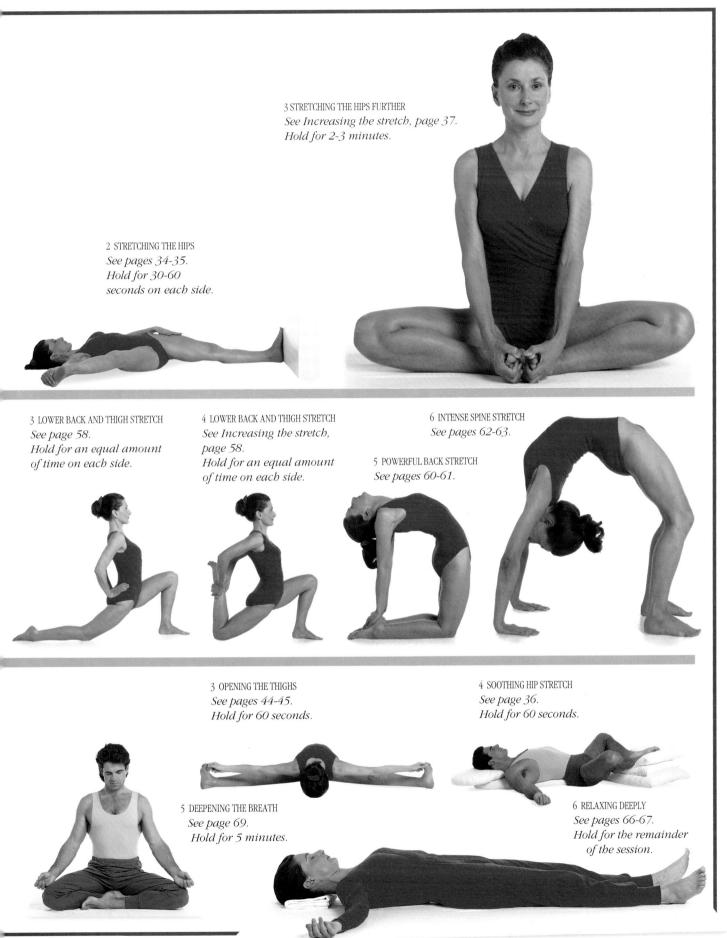

3 STRETCHING THE HIPS FURTHER
See Increasing the stretch, page 37.
Hold for 2-3 minutes.

2 STRETCHING THE HIPS
See pages 34-35.
Hold for 30-60
seconds on each side.

3 LOWER BACK AND THIGH STRETCH
See page 58.
Hold for an equal amount
of time on each side.

4 LOWER BACK AND THIGH STRETCH
See Increasing the stretch,
page 58.
Hold for an equal amount
of time on each side.

6 INTENSE SPINE STRETCH
See pages 62-63.

5 POWERFUL BACK STRETCH
See pages 60-61.

3 OPENING THE THIGHS
See pages 44-45.
Hold for 60 seconds.

4 SOOTHING HIP STRETCH
See page 36.
Hold for 60 seconds.

5 DEEPENING THE BREATH
See page 69.
Hold for 5 minutes.

6 RELAXING DEEPLY
See pages 66-67.
Hold for the remainder
of the session.

3
STRETCHING INTO SHAPE

Very few of us have a perfect body
shape, but we can define muscle tone
and enhance our shape by stretching
deeply into the joints and relaxing the
nerves. These programs target key
areas of the body with stretches
that sculpt and tone to leave the
whole body glowing with
health and vitality.

Enhancing the Body

THE PERFECT PHYSIQUE is the exception, not the rule, but by stretching everyone can make positive changes in his or her body, become slimmer, and more shapely. Body shape is determined by many factors — body type, gender, concentration of fat, muscle tone, and posture — according to the individual. Yet all of us — especially women — are under great media pressure to conform to stereotyped ideas of beauty. The following daily stretches improve all-round health and self-awareness, and in this way alter body shape subtly. This is not one of the many short-lived forms of exercise, promising instant transformation by making rigorous demands on the body. The foundation of the program is based on hatha yoga, proven over 3,500 years to be remarkably efficacious in promoting well-being. It involves the body, emotions, and mind, acknowledging the intricacies of the joints and muscles and recognizing that if the body is to change, it must do so gradually to give each muscle time to adjust.

Each series of stretches is designed to fit into and complement a daily program, for only by working the whole body regularly can the shape of specific areas be altered. Practice is the key to change: the more you practice, the easier it becomes. It is exciting to see gradual changes happen at any age, as stretches tone muscles, restore youthful posture, and leave the body glowing. Each program pinpoints a specific problem area: the face and neck, the shoulders and bustline, the waist, thighs and buttocks, and the legs and ankles. Key stretches are indicated in each program. Focus on these in your daily stretch, adding in the new poses when you wish to work a little harder.

Stretch the feet, reduce puffiness, and improve posture with sitting stretches and inverted poses

Improve circulation in the legs and relieve varicose veins by sitting between the feet and bending forward

Releasing the shoulders, opening the chest, and lifting the upper back alleviate a caved-in silhouette

Relaxation softens the facial muscles, helping the eyes look more alive and slowing wrinkle development

Strengthen the abdominal muscles and reduce fat by lengthening the lower back and twisting

Firming the pelvic muscles keeps the abdomen toned and reduces fat around the hips

Stretching the upper back improves the bust

Working the upper back, shoulders, and neck prevents 'dowager's hump' and reduces aging in the neck

Stretching the spine (especially upside down) and deep breathing improve circulation and lymphatic drainage. Good for the skin, this helps prevent cellulite

Firm the thighs, improve their shape, and reduce fat with standing stretches

Rejuvenating the Face

LIFTING THE CHIN, extending the neck, and relaxing the face gently and effectively rejuvenate this sensitive area of the body. Relaxing the face is, without a doubt, a key way to ease the drawn, tired look that ages us, for stress, combined with poor nutrition and the build-up of toxins and waste in the body, harms hormone production, and no amount of beautifying skin-care products can remedy its effects.

KEY DAILY STRETCHES

Backward stretches *In your daily stretching, practice the simpler stretches on pages 55-59, and then add the new stretches here. No strain should be felt on the lower part of your throat. The movement should come from lengthening the upper spine back and extending the neck in a comfortable curve.*
Inverted stretches *(pages 46-49) are effective at the end of your stretching before you start to relax.*
Relaxation *Choose the most comfortable pose from pages 64-69 and relax for ten minutes each day; or try sitting with your body stretched along your thighs (page 42).*

CHIN TONER

Lengthening backward is a wonderful way to tone the throat and stretch the platysma muscle beneath the chin. It allows gravity to lift the facial muscles and boost circulation. Try this stretch after forward bends (pages 40-45) or inverted poses (pages 46-49).

1 Sit with your knees bent, feet flat on the floor. Place the palms of your hands close to your hips, making sure that your fingers are pointing forward, toward your feet.

2 Exhale, lift your hips toward the ceiling, and straighten your arms. Press your palms down, keeping your wrists in line with your shoulders. Gently stretch your neck, and bring your head back as far as you can without straining your throat. Hold for 30-60 seconds, breathing normally.

Keep the hips high

3 If you can, stretch your legs straight, keeping your hips lifted, and hold for 30-60 seconds. Breathing out, bend your elbows and knees, and bring your hips to the floor.

NECK STRETCH

If you have a strong, flexible spine, use this intense stretch as a skin treatment, for it works the facial muscles and boosts circulation to the chest. Practice it after the stretches on pages 54-56, but if you are a beginner, continue to practice the less advanced stretch on page 56.

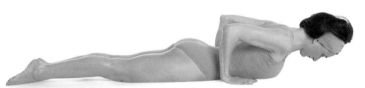

1 Lie on your abdomen, stretch your legs and point your toes. Place your palms by your hips. Inhale. Raise your trunk. Breathe out, straighten your arms, and curve your spine, your pubis on the floor.

2 Press down, stretch your spine, and lift the back of your head. Feel the movement in your sacrum, and lengthen your upper back. Breathe normally. Hold for 20 seconds. Bend your elbows, breathe out, and rest on the floor. Repeat two or three times.

Lengthen the upper back while lifting and expanding the chest

ARM BALANCE

Inverted stretches are excellent for the complexion, for they encourage blood circulation in the throat and face. Try this stretch if you have a flexible upper spine and strong arms.

1 Place your hands shoulder-width apart (further if you have stiff shoulders) on the floor, about 3 in. (7 cm.) from a wall. Spread your palms and fingers. Bend your left leg in front of the right, straight leg. Stretch the arms, elbows, and shoulders. Push your weight onto your left foot. Open your chest.

2 Bring your hips near the wall (do not bend your elbows). Lift your right leg. Jump from your left foot, swinging right, then left leg to the wall. Stretch up from your arms to your feet. Relax your face and neck, or look back. Hold as long as you can. Bring the legs down on an out-breath.

Let the neck relax and feel the blood circulate to the face

Keep the arms strong and straighten the elbows

Toning the Upper Body

STOOPED SHOULDERS and a rounded upper back are not only unflattering, they make the chest appear caved in. Stretching the shoulders, freeing the upper back, and opening the chest can transform both the male and female silhouette. These types of stretches further enhance the female form by lifting and firming the bustline, and reducing the unsightly lump at the base of the neck. While re-shaping the body, these stretches can also be part of a daily stretch.

KEY DAILY STRETCHES

Inverted stretches *(pages 46-49) ease a stiff upper back and reduce 'dowager's hump'. Lifting up on blankets lengthens the muscles and aligns the neck vertebrae.*
Backward stretches *Use strengtheners (pages 55-59) to elongate the upper back. Introduce more intense stretches (pages 60-63) when stronger and more flexible. To improve your bustline early on, include the stretches here daily.*
Standing stretches *Try the stretch on pages 30-31. To firm the triceps, stretch the back of the upper arms firmly.*
Twisting stretches *(pages 50-53) free the rib cage. For maximum benefit, pull the shoulders back and down when interlocking the hands.*

UPPER BACK RELEASE

This exercise really works upon the muscles around the breasts. Practice it slowly, sitting or standing, concentrating on the release of your shoulder muscles from deep within, and feeling your upper back extend as, little by little, you increase the range of the stretch.

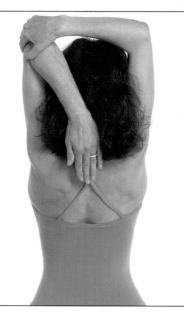

1 Stand or sit between your feet. Extend your arms, with palms facing. Turn them in, triceps forward. Breathing out, drop your left hand behind your back. Take the upper part of your left arm in your right hand and draw it to the head. Hold for several breaths.

2 Turn your right arm out, palm up. Bend your elbow. Bring the back of your forearm to your spine. Draw the right elbow down and in with your left hand. Flatten your palm. Work the right shoulder back. Let go after a good stretch. Repeat on your left arm.

3 Bend your right arm behind your back, as step 2. Stretch your left arm up, bend your elbow, and catch your right hand. Roll your right shoulder back and move your upper spine in. Keep your spine lifted, palms flat. Hold, breathing deeply, for 30 seconds.

SHOULDER EXTENSION

Fully stretching the arms and opening the shoulders away from the spine help develop the arms and, in women, lift the bustline.

1 Sit on a blanket. Place a cushioned block between your feet. Interlock your fingers, right thumb on top. Stretch your arms forward at shoulder level, palms out.

2 On a deep out-breath, stretch up through the arms and wrists. Open your palms. Hold for 15-20 seconds, breathing evenly. On an out-breath bring the arms down. Interlock the fingers, left thumb on top, and repeat.

Create space for the diaphragm

UPPER BACK EXTENSION

Stretching the upper spine opens up the chest and corrects a stooping posture. This creates a confident appearance and good flow of breath.

Stand with feet hip-width apart. Interlock your fingers behind your back. Stretch your arms up and as far back as you can. Breathe out and bend forward. Let your arms come as far over your head as possible without forcing them.

Bend forward from the hips

Bring the arms as far forward as possible

GENTLE BACK STRETCH

Bending back promotes easy breathing and gently shapes the body by freeing the upper back, working the shoulders, and expanding the ribs.

Make sure the blanket is firmly rolled

Lie with a rolled blanket under the upper back, legs extended. Tuck the shoulder blades under and open your chest by bending the arms and pressing on the elbows. Carefully place the edge of your shoulders down so they just roll off the blanket. Elongate your buttocks. Rest your head back and extend your arms.

Defining the Waist

THESE STRETCHES FIRM the abdomen and accentuate the waist, key areas in terms of body shape for both sexes. Although women have a larger ratio of fat to muscle, men accumulate fat around the waist and hips if overweight, and even those who are slim can have bulging tummies from bad posture. Side twists work wonders in reducing fat around the abdomen, and by massaging the organs they also cleanse the body, removing waste from the colon.

KEY DAILY STRETCHES

Stretching sideways (pages 50-53) reduces fat around the abdomen and stimulates sluggish bowels and liver. The detoxification this promotes helps all the body's systems work at peak form, further aiding weight control.
Standing stretches (pages 22-24, 26-33) reduce lumbar lordosis (see page 17), bringing the pelvis into a balanced position which tones the abdominal muscles.
Forward bends (pages 40-45) lift the abdomen, making us aware of even a slight excess of fat in this area.
Back bends (pages 54-63) have a slimming effect on the waist and abdomen.

ABDOMEN TONER

Let this stretch tone and firm your abdominal muscles, as you extend one side of your abdomen while flexing the other.

Kneel, tailbone tucked in. Stretch the tops of your feet down flat. Extend your left leg to the side, heel in line with right knee. Stretch your arms at shoulder level. Exhale. Stretch your trunk left, left arm down. Extend from the hips. Bring the right arm over your head toward your left hand. Hold for a few seconds, breathing normally. Come up on an in-breath. Exhale. Repeat to the right.

Stretch the arm over the head, extending from the hips

Keep the knees together

GENTLE ABDOMEN STRETCH

Try this restful pose after standing stretches. If you cannot sit between your feet, sit on a firm cushion, interlock your fingers and stretch up.

1 Sit between your feet, buttocks on the floor. Breathing out, stretch back and rest each elbow on the floor. Slide your elbows out and let your trunk rest on the floor. If uncomfortable, support your spine with a bolster or rolled blanket (see page 99).

2 Stretch your arms over your head or fold them behind the head (see page 99). Keep the knees together. Hold for up to five minutes, breathing normally. To come up, lift onto the elbows, sit up, and release each leg.

GOOD POSTURE

Maintaining a youthful posture can transform the body's silhouette, for standing correctly tones the abdominal muscles, making the stomach look flatter.

Lengthen the back of the waist

Stand tall with your heels against a wall. When you stand well, the back of your head and chest and your sacrum touch the wall, and the spine curves in softly at the neck and waist. Maintain the horizontal balance of your pelvis, and lift your spine.

Straighten the knees

Keep the heels touching the wall

INTENSE TWIST

Add this more intense twist, which strengthens and flattens the abdomen, to your standing stretches after stretching to the side.

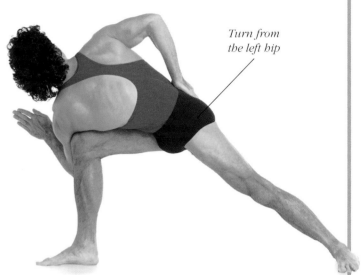

Turn from the left hip

1 Stretch up. Jump your feet wide and extend your arms. Turn your left foot in, your right out, lining up the heel with the left arch. Bend your right knee at 90°. Lift your left heel. Turn from the pelvis, bringing your left elbow over your bent knee.

2 Straighten your left arm, and rest your fingers on the floor by your foot. Stretch your right arm over your head, palm down, and keep extending your left leg. Hold for 20-30 seconds, breathing normally. Release on an in-breath. Repeat the stretch on the other side.

Firming the Thighs

THE THIGHS OFTEN NEED special attention, and, for women, unsightly cellulite may be a problem. The thighs can be slimmed by improving the metabolism, and their shape can be defined by developing muscle tone. These exercises also firm the buttocks for a sleek, elegant line from hip to thigh.

KEY DAILY STRETCHES

Standing stretches *Choose the stretches on pages 22-24, 26-33. When practicing stretches with a bent knee, keep the thigh parallel to the floor to work the outer hip and thigh.*
Back bends *(pages 54-63) firm the muscles and provide extra support for the lumbar vertebrae.*
Hip stretches *Practice any stretches that increase flexibility in the hips (pages 40-45).*

INNER THIGH SHAPER

Lengthen the hamstrings and firm the inner thighs by practicing this stretch with other hip stretches in your program (pages 40-45). If you have difficulty balancing, practice against a wall or sofa.

1 Lie on your left side, stretch your left arm, and extend your left side from heel to fingertips. Bend your left elbow, and support your head with your left hand. Bend your right knee, and catch your big toe (loop a belt around your foot if you find this difficult).

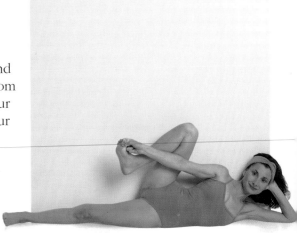

Keep extending the leg as you hold the stretch

2 Straighten your right knee and arm as you stretch your leg close to your head. Hold the stretch, breathing normally, for 30-60 seconds. Bend your knee, release your leg, and repeat on the other side.

86

OUTER HIP STRETCH

When practicing sitting stretches, try this pose which benefits the outer hips. If your thighs are large or your hips very tight, this stretch can be difficult, so practice gently at first.

Sit with one thigh crossing the other. Move your shins as far out as you can, until almost in line with each other. Support yourself by holding your feet. Sit up tall. Hold for 30-60 seconds, breathing easily. Repeat with legs crossed the opposite way around.

BUTTOCK AND THIGH FIRMER

Standing stretches tone the outer hips and give a sleek look to the tops of the thighs. Try this pose after standing stretches, or, as you gain movement in the sacrum, after STRETCHING UP (page 24), turning out from the hips.

Stand in front of a chair, feet apart, turned out wide. Contract your anal muscles, tuck in your coccyx, and stretch up. Hold the chair. Bend your knees out in line with your feet. Breathing out, descend as far as you can. Take a breath or two. To come up, press the heels down, and squeeze the anal muscles, tailbone tucked in. Repeat five to ten times.

BACK STRETCH

The contraction of the muscles around the coccyx and inner thighs draws the buttock muscles away from the back of the waist, bringing tone and firmness to them.

Squeeze the thighs inward

Lift the hips: do not push up from the curve at the back of the waist

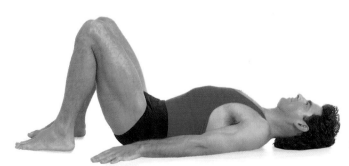

1 Lie on your back with your knees bent and your feet flat on the floor. Keep the length of your back on the floor, and rest your arms by your side. Then start to contract your buttock muscles.

2 Lift your hips. Hold, breathing normally, lifting the pubis higher than the navel. When your thighs ache, exhale and descend. Repeat twice if doing other back stretches; three to five times if not.

Shaping the Legs and Ankles

TONING AND DEFINING the leg muscles, and strengthening and slimming the ankles, are essential elements when re-shaping your body. Stretching the toes and strengthening the arches of the feet will improve balance and enhance the entire posture. When the feet are stretched and relaxed, the whole body feels and looks good.

KEY DAILY STRETCHES

Standing stretches (pages 22-24, 26-33) are essential in a daily stretch. For most benefit, stretch the feet well, and extend the toes (in back stretches too). Lift from the arches of the feet, press the heels down, and stretch the ankles up.
Whole body stretch Choose the stretch on pages 38-39 to work the feet and ankles, and shape the leg muscles.
Forward bends (pages 40-45) strengthen the knees, release tight legs, and work the arches of the feet.

TONING THE ARCHES

Feet often suffer when we wear unsuitable shoes, so treat them with this stretch, which relieves aching feet and improves the arches.

Kneel, feet and ankles together. Sit on your heels, and distribute your weight evenly. Tie a belt around your ankles to keep them well together. Stretch your spine up. If you are heavy or it is hard to sit on your heels, don't use a belt; place a cloth beneath your ankles. If your big toes press together, put a cloth between them.

Stretch through the ankles, the arches of the feet, and the toes

ANKLE SLIMMER

While lengthening the ankles and making them slim and more flexible, this stretch strengthens the feet too. Try it during standing stretches, with your hips against a wall if it is too strenuous.

1 Stand up straight, feet together, parallel to each other. Breathing out, stretch the arms above the head, palms together.

Draw the body up as the legs bend

2 Breathing out, deeply bend your knees, while pressing your heels down into the floor. Stretching the backs of your legs and your Achilles tendons, bend as if sitting on a stool. Come up on an in-breath, and repeat two or three times.

LEG TONER

This stretch tones the legs, strengthens the ankles, and improves balance. Practice it after stretching up, supported by a wall if you wish.

1 Stand straight, with feet together. Bend your left knee, and catch your foot. Place your heel high on your inside right thigh, toes down. Move your left knee back to open the thigh. Rest the right hand on the hip for balance.

Rotate the leg back

Lift the front thigh muscles

2 Without pulling the right hip out of line, lift up through your right thigh and pelvis. Extend your arms to the side, palms facing the ceiling. Breathing out, stretch your arms up while extending your spine. Focus on a spot in front to help you balance, and breathe effortlessly. Repeat on the other leg.

LEG BALANCE

This elegant stretch is especially beneficial for shaping the legs and ankles, and by increasing balance, it also focuses the mind.

1 From standing, go into EXTENDED STRETCH (pages 28-29). Bring the right arm along the right side of the trunk. Exhale, then bend your left knee and place your left hand 12 in. (30cm.) from your left foot. Bring the right foot in closer.

Stretch the toes

Pull up the thigh muscles

Lift the body

2 Breathing out, lift the back leg, and stretch your left arm and leg. Balance, while breathing normally. Turn the lower abdomen up, take back the right hip, and stretch along the spine. Raise the right arm in line with the left. Look at the fingertips. Hold for 20-30 seconds. Repeat on the other side.

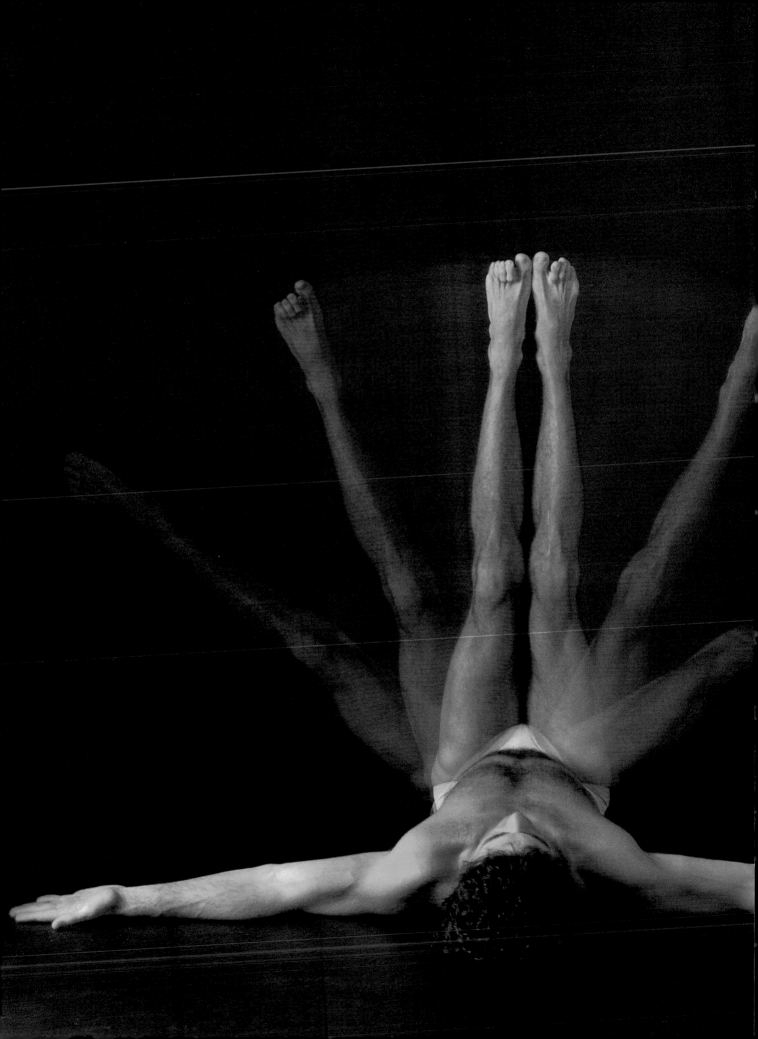

4
LIFESTYLE PROGRAMS

Everything we do is recorded in our bodies. Strain and stress deplete vital energy, and an unhealthy lifestyle wastes our physical energy. Stretching the body, relaxing, and breathing deeply restore vital energy and clear the mind, freeing us from aches, pains, and mental stress.

Stress and the Body

WE ALL HAVE AMAZING POTENTIAL for health and well-being and the power to help heal ourselves when sick. When we are healthy, we have access to all our energies and can experience the joy of being fully alive. The lifestyle we lead can encourage this, or it can deprive us of the feeling of fulfilment. Unfortunately, we live with many forms of stress. The air we breathe is polluted with lead and other toxins, our food is contaminated with pesticides and industrial chemicals. Stimulants such as cigarettes and alcohol, medication, and lack of exercise affect our health adversely too. For many of us, work takes up the major part of the day, and here we are subjected to other kinds of stress. Machines may have reduced some of the physical strain, but sitting or standing in one place, making few expansive movements, affects our posture and circulation. Commuting, air conditioning, central heating, and the bombardment of noise from computers and telephones can make us feel trapped and angry. Bad working relationships and the pressure to achieve also take their toll. The body bears the signs of mental as well as physical tension. Exhaustion and depression are on the increase, especially among young women; high blood pressure and heart disease are no longer associated only with the executive. Unemployment and financial pressures cause anxiety and anger, and the stress of bereavement or broken relationships can affect anyone.

KEY STRESS AREAS

These areas of the body are especially susceptible to the effects of stress. To remedy a particular stress point in your own body, follow the stretch program indicated.

NECK *A delicate area, the neck is susceptible to stress, which makes it tighten and block circulation to the brain. This results in headaches. See* **Winding Down** *(pages 96-97).*

SHOULDERS AND UPPER BACK *Sitting or bending over for long periods causes stiffness. See* **Relieving Stiffness** *(pages 102-103). Tense shoulders and backache are common after a long day at work. See* **Topping Up Energy** *(pages 98-99).*

ABDOMEN *Stress caused by frustration, aggression, and bad diet can cause digestive problems. Physical fatigue, nervous exhaustion, and anxiety cause the release of adrenalin. This eventually lowers blood sugar levels and creates a craving for stimulants. See* **Winding Down** *(pages 96-97).*

LEGS AND FEET *Standing or sitting for hours at the office or at home, in cars or planes may result in aching legs and feet and swollen ankles. See* **Topping Up Energy** *(pages 98-99).*

HEAD *Over-activity of the brain may cause dizziness and headaches. Mental fatigue can cause insomnia, impairing performance. Long hours of concentration may leave the brain unable to switch off. See* **Diffusing Tension** *(pages 100-101).*

EYES *Using computers and other machines can cause soreness and eye strain. See* **Diffusing Tension** *(pages 100-101).*

TORSO *Under stress, the body may feel sluggish, with no energy, and need a revitalizing and detoxifying workout. See* **Get Up and Go** *(pages 94-95).*

LOWER BACK *The back may ache and feel stiff after using badly designed chairs. See* **Relieving Stiffness** *(pages 102-103).*

HANDS *Typing, using machines, or playing musical instruments can make the fingers and wrists ache or suffer from cramps and tightness. See* **Relieving Stiffness** *(pages 102-103).*

Many people are seeking some type of self-help to counter the stress caused by such adverse conditions, attempting to balance their lifestyle, and improve health and well-being. We can start to take control of our bodies by exercising regularly, and by balancing times of activity with total relaxation away from distraction and noise, for relaxation is not a luxury but an essential part of daily life. Selecting a diet that does not over-load the digestive system and is rich in whole, nutritious foods is also important. No one's life can run smoothly all the time. But by relaxing and taking control of our lives, we can learn to respond in the right way to fraught emotional situations, rather than relying on medication or stimulants.

The five programs that follow are suitable for anyone in reasonable health, and they have been created especially to release daily tension and relieve everyday worries. Use them if your daily routine is upset, when you feel weak or tired, or when you need extra energy, referring to Part 2 for full instructions to each stretch. The stretch sequences can be practiced instead of your daily program, or you may want to practice the relaxing program (pages 96-97) in the evening to complement your regular morning stretch. If any stretch is too difficult, refer to Part 2 and select an easier version, perhaps using props. If you are menstruating, omit the upside-down poses and strenuous stretches.

Get Up and Go

WHEN YOU NEED TO BOOST energy and feel vital and dynamic, try this flowing jumping routine. Based on the sun cycle of leading yoga authority B.K.S. Iyengar, it deepens breathing, boosts circulation, and energizes. Practice it when you feel at home with the basic program (pages 70-71), unless you have injuries, are pregnant or menstruating.

PRACTICE

Up to 20 minutes

Jump with both feet and breathe regularly, breathing in on the first pose, out on the second, and so on. In BACK LIFT use the feet and arms well to avoid compression in your lower back. In HORIZONTAL STRETCH tuck your toes under and bend your elbows so your body is parallel with the floor. Start slowly, making each stretch precise and full, and repeat the whole sequence several times. As you get stronger, build up to 20 minutes' practice, creating a light and detoxifying sweat.

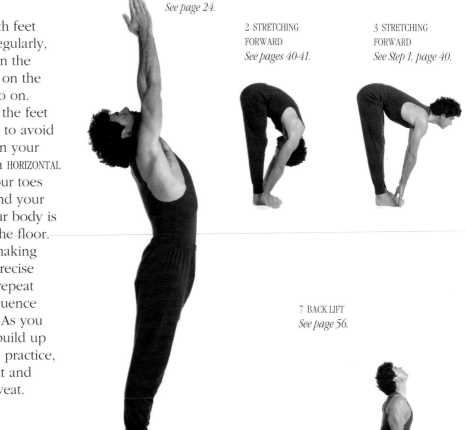

1 STRETCHING UP
See page 24.

2 STRETCHING
FORWARD
See pages 40-41.

3 STRETCHING
FORWARD
See Step 1, page 40.

7 BACK LIFT
See page 56.

RELAXATION

10 minutes

After completing several sequences rest by bending forward. Then sink into deep relaxation to refresh your body and mind completely.

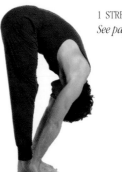

1 STRETCHING FORWARD
See pages 40-41.

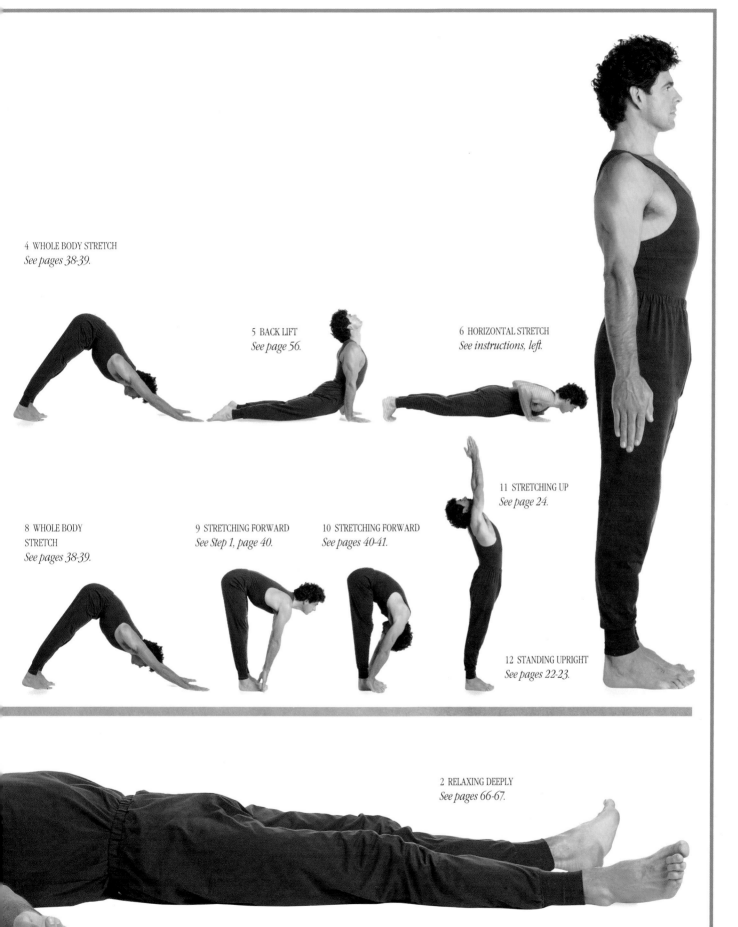

4 WHOLE BODY STRETCH
See pages 38-39.

5 BACK LIFT
See page 56.

6 HORIZONTAL STRETCH
See instructions, left.

11 STRETCHING UP
See page 24.

8 WHOLE BODY
STRETCH
See pages 38-39.

9 STRETCHING FORWARD
See Step 1, page 40.

10 STRETCHING FORWARD
See pages 40-41.

12 STANDING UPRIGHT
See pages 22-23.

2 RELAXING DEEPLY
See pages 66-67.

Winding Down

DURING VERY BUSY times when the mind is really active, it can be hard to calm down, and we may turn to stimulants: a cigarette, coffee, or a stiff drink. In time, the adrenal glands suffer; hair, skin, and nails deteriorate; and depression can result from deep-seated exhaustion. Releasing tension and calming the nervous system let mind and body rest.

PREPARATION

Up to 5 minutes

Unlock tension in the neck and upper back. If you wish, place your head on a block in WHOLE BODY STRETCH, and use firm cushions in STRETCHING FORWARD.

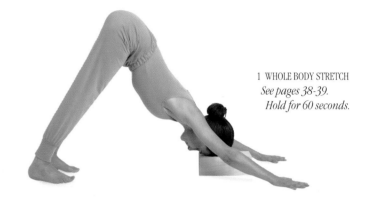

1 WHOLE BODY STRETCH
See pages 38-39.
Hold for 60 seconds.

PRACTICE

About 15 minutes

Begin to wind down, using cushions where needed. These keep the body supported well and free from strain, allowing the muscles to relax and the brain to become less agitated. If you are not comfortable sitting on the floor in any of these stretches, sit on a soft blanket.

1 HAMSTRING STRETCH
See step 2, page 43.
Hold for 60 seconds
on each leg.

2 HAMSTRING STRETCH
See page 43. Hold for
60 seconds on
each leg.

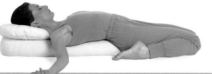

5 GENTLE ABDOMEN STRETCH
See page 84.
Hold for 3-5 minutes.

RELAXATION

10 minutes

Relax on your back until you feel calm and quiet. As your nervous system is gradually calmed, relinquish control and sink into relaxation. Finish in a kneeling position, breathing slowly, quietly, and deeply.

1 RELAXING DEEPLY
See pages 66-67.
Hold for 5 minutes.

2 STRETCHING FORWARD
See Easing the stretch, page 41.
Hold for 60 seconds.

3 STRETCHING FORWARD
See pages 40-41.
Hold for 1-2 minutes.

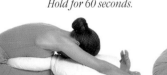

3 RELAXING FORWARD
See page 42.
Hold for 60 seconds.

4 OPENING THE THIGHS
See Easing the stretch, page 45.
Hold for 60 seconds.

7 FULLY INVERTED STRETCH
See Easing the stretch,
page 48. Hold for
5 minutes.

6 SOOTHING HIP STRETCH
See page 36. Hold for 1-3 minutes.

2 DEEPENING THE BREATH
See Easy breathing, page 69.
Hold for 5 minutes.

Topping Up Energy

IF YOU ARE FEELING tired because you are understimulated, perhaps after spending a long, fruitless day in the office, or sitting for long periods, try this stretch program. It lifts the draining fatigue, aching back, and tight shoulders that result from bad sitting habits, and it stimulates circulation, reducing swelling in the feet and legs.

PREPARATION

About 5 minutes

When self-motivation is hard, the last thing you want is exercise, but this is precisely the boost you need to break the cycle of lethargy. Start by releasing the shoulders, refreshing the legs and feet, and stretching the spine and abdomen.

1 STRETCHING UP
See page 24.
Hold for 60 seconds.

2 UPPER BACK RELEASE
See page 82.
Hold for 30 seconds
on each arm.

PRACTICE

Up to 10 minutes

Now focus on strongly stretching the spine and making free, expansive movements with your limbs. Extend fully into each stretch, and rest between each one. If you wish, use blocks to help you stretch.

1 STRETCHING SIDEWAYS
See pages 26-27.
Hold for 30-60 seconds on
each side. Repeat twice.

2 EXTENDED STRETCH
See pages 28-29.
Hold for 30-60 seconds
on each side.

RELAXATION

Up to 15 minutes

Continue to release the spine with a gentle twist. Then drain the lower body, recycling the stale blood and lymphatic fluid. Finally, let your whole body relax to top up energy for the evening ahead.

1 GENTLE TWIST
See page 50.
Hold for 30 seconds
on each side.

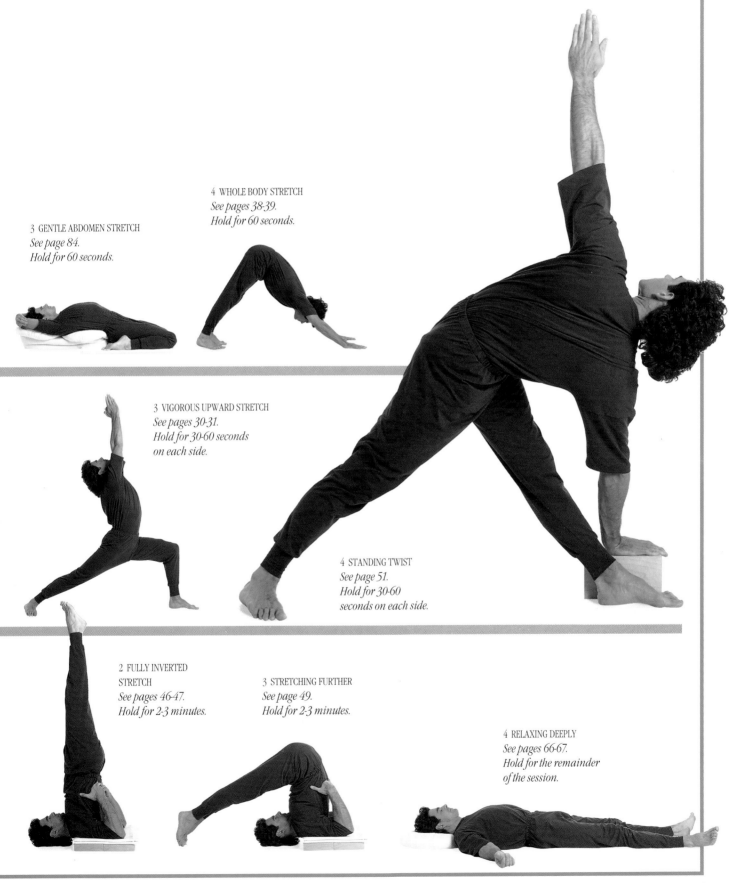

3 GENTLE ABDOMEN STRETCH
See page 84.
Hold for 60 seconds.

4 WHOLE BODY STRETCH
See pages 38-39.
Hold for 60 seconds.

3 VIGOROUS UPWARD STRETCH
See pages 30-31.
Hold for 30-60 seconds
on each side.

4 STANDING TWIST
See page 51.
Hold for 30-60
seconds on each side.

2 FULLY INVERTED
STRETCH
See pages 46-47.
Hold for 2-3 minutes.

3 STRETCHING FURTHER
See page 49.
Hold for 2-3 minutes.

4 RELAXING DEEPLY
See pages 66-67.
Hold for the remainder
of the session.

Diffusing Tension

YOUR EMOTIONAL STATE is recorded in your body: if you are happy, the muscles relax and movement is easy; if you are stressed or sad, the muscles contract and all the body's systems are impaired. When your equilibrium is disturbed and it is difficult to sleep or carry on as usual, make expansive actions that shift negativity before relaxing.

PREPARATION

Up to 15 minutes

Start with standing stretches to reverse an inward-looking stance. Breathing well, expand into each stretch. Use props, such as blocks or a chair, to open the chest. If you feel weak, just work from LONG BACK STRETCH to BREATHING LYING DOWN, and increase the time you hold each one.

1 STRETCHING UP
See page 24.
Hold for 30-60 seconds.

2 SHOULDER RELEASE
See page 82.
Hold for 30-60 seconds on each side.

3 STRETCHING SIDEWAYS
See pages 26-27.
Hold for 30-60 seconds on each side.

PRACTICE

10 minutes

Inverted poses cleanse cells of the metabolic waste that builds up with stress. Brain, neck and chest benefit from improved circulation, relaxation is easier, and stress starts to diminish. Use cushions if needed.

1 FULLY INVERTED STRETCH
See Easing the stretch, page 48.
Hold for up to 5 minutes.

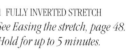

RELAXATION

5 minutes

During relaxation the body starts to replenish its reserves of energy, and this helps the mind remain positive during stressful times.

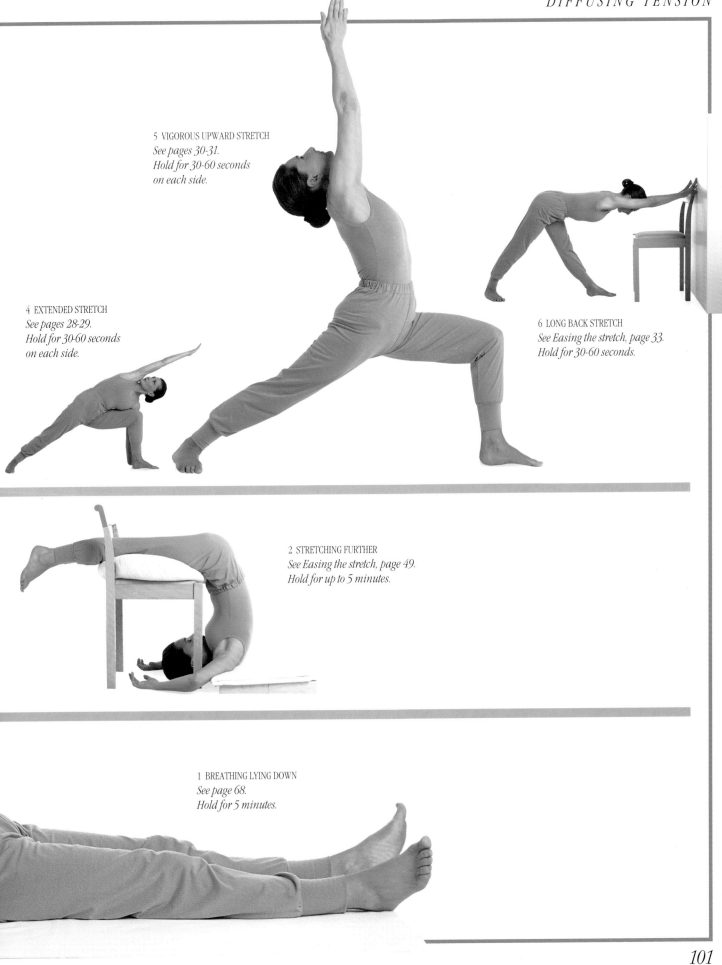

5 VIGOROUS UPWARD STRETCH
See pages 30-31.
Hold for 30-60 seconds
on each side.

4 EXTENDED STRETCH
See pages 28-29.
Hold for 30-60 seconds
on each side.

6 LONG BACK STRETCH
See Easing the stretch, page 33.
Hold for 30-60 seconds.

2 STRETCHING FURTHER
See Easing the stretch, page 49.
Hold for up to 5 minutes.

1 BREATHING LYING DOWN
See page 68.
Hold for 5 minutes.

Relieving Stiffness

A NUMBER OF DIFFERENT factors affect how stiff you feel from day to day: stress, diet, depression, and the way you sit and stand. Aches and pains also set in if movement is restricted by clothing, shoes, or even by emotions. Other stiffness is job-related, the result of long periods of sitting, standing, lifting, or repetitive movements.

PREPARATION

Up to 10 minutes

Start by easing stiffness in the shoulders, neck, hands, hips, and legs. When STRETCHING FORWARD stretch out to a wall, as here, or to a chair.

1 STRETCHING FORWARD
See Easing the stretch, page 41.
Hold for about 3 minutes.

PRACTICE

About 10 minutes

Now bring the body back into equilibrium by stretching the lower back and spine, and releasing the legs and shoulders. Use blocks or blankets if you need help easing into any of the stretches.

1 STRETCHING SIDEWAYS
See pages 26-27.
Hold for 30-60 seconds
on each side.

RELAXATION

10 minutes

Lastly, stretch the back, and let the brain relax. Reach out to a block in FULL BACK STRENGTHENER, and use folded blankets in HAMSTRING STRETCH and RELAXING FORWARD.

1 FULL BACK STRENGTHENER
See Easing the stretch, page 57.
Hold for 60 seconds.

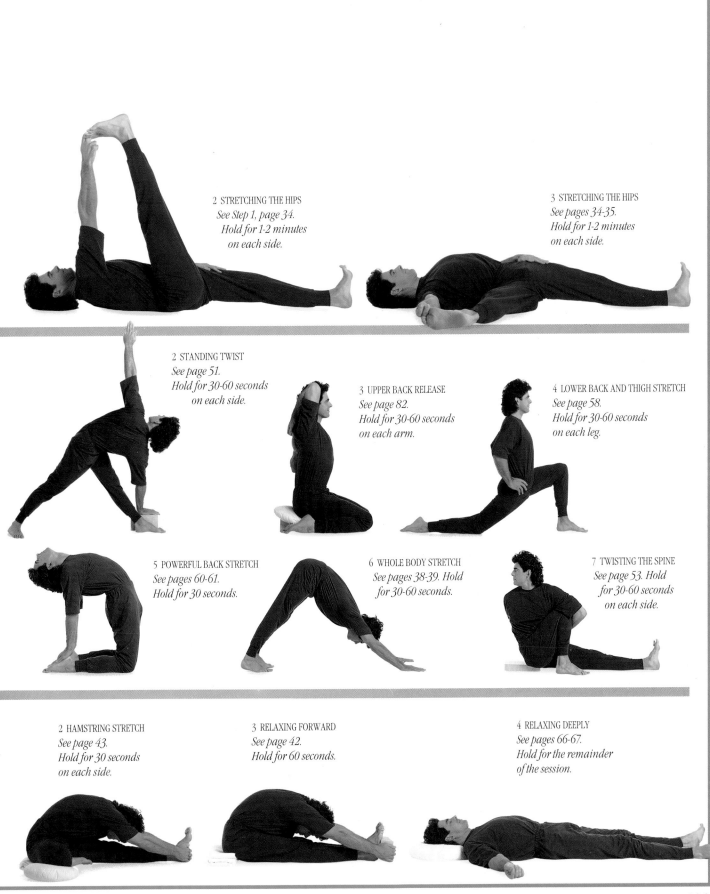

2 STRETCHING THE HIPS
See Step 1, page 34.
Hold for 1-2 minutes
on each side.

3 STRETCHING THE HIPS
See pages 34-35.
Hold for 1-2 minutes
on each side.

2 STANDING TWIST
See page 51.
Hold for 30-60 seconds
on each side.

3 UPPER BACK RELEASE
See page 82.
Hold for 30-60 seconds
on each arm.

4 LOWER BACK AND THIGH STRETCH
See page 58.
Hold for 30-60 seconds
on each leg.

5 POWERFUL BACK STRETCH
See pages 60-61.
Hold for 30 seconds.

6 WHOLE BODY STRETCH
See pages 38-39. Hold
for 30-60 seconds.

7 TWISTING THE SPINE
See page 53. Hold
for 30-60 seconds
on each side.

2 HAMSTRING STRETCH
See page 43.
Hold for 30 seconds
on each side.

3 RELAXING FORWARD
See page 42.
Hold for 60 seconds.

4 RELAXING DEEPLY
See pages 66-67.
Hold for the remainder
of the session.

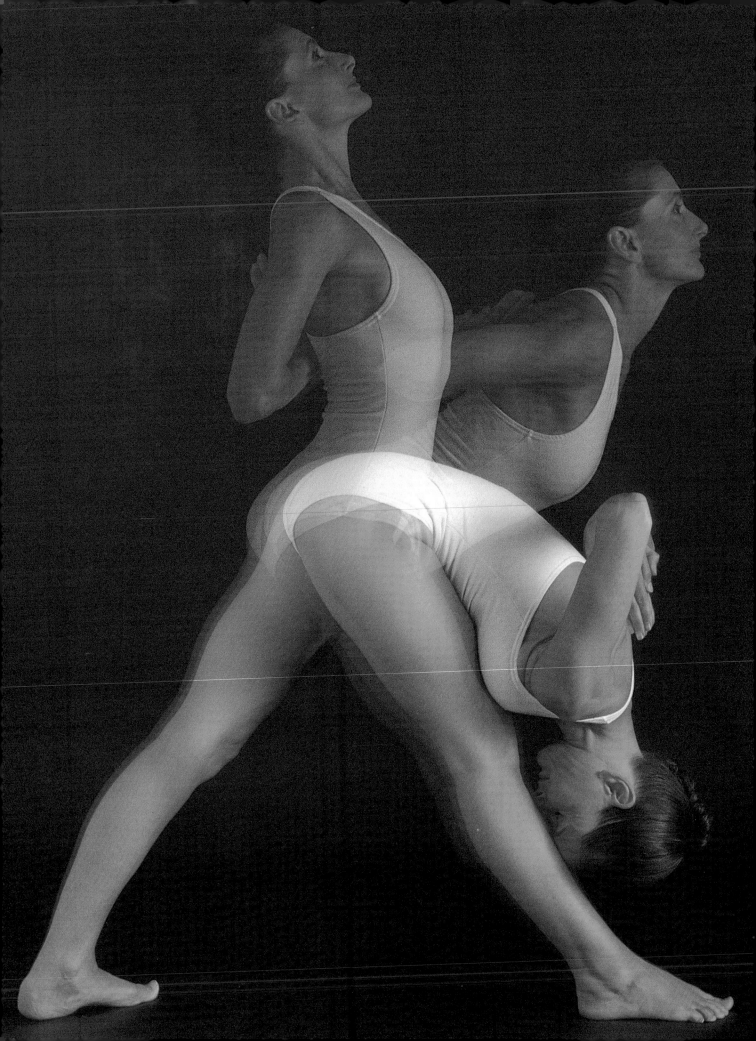

5
STRETCHING FOR SPORT

Stretching is the perfect complement
to virtually any sport. Whereas most
sports overwork certain areas of the
body, stretching gives the whole body
a thorough workout, encouraging
even muscle development and
improving speed and technique.
Stretching also aids concentration
and reduces fatigue and stiffness,
helping prevent injury.

Stretching for Success

FOR THE PERSON WHO enjoys recreational sport, the professional athlete, and the keen competitor alike, stretching improves speed and technique, helps prevent injury, and encourages successful participation well into old age. A daily stretch keeps the body strong and flexible. Stretching before a game improves specific skills; after sport it releases muscles and re-balances the body to prevent stiffness. Follow a stretch with deep relaxation to promote a feeling of well-being, vital whether you win or lose.

IMPROVING TECHNIQUE

Until recently athletes tended to build strength and endurance, using stretching as a remedial aid to ease muscles tightened by injury, over-use, or age. Now, stretching is recognized as a key way to improve performance and speed too. Balancing strength, stamina, and flexibility — preventative body conditioning — is the way to the top for today's athletes.

Although stretching the key muscles used in a sport before you play is an effective warm-up, such isolated stretches alone cannot build the type of flexibility that improves performance. Linking them with a daily program (pages 70-75) is the only way to balance muscle groups and align the bones to create effective change. For good technique the body needs more than an average range of movement in the joints, and the world's top athletes are superior to merely good competitors not only in strength and endurance, but in the specific kind of flexibility for their sport. At his peak, John McEnroe's outward arm rotation measured 90°, and this accounted for much of the speed and power of his service. Golfers can add 20 yards to their drive with increased hip flexibility; runners can increase their speed, for poor flexibility shows up in lack of speed. As a professional footballer, John found this to be true. Having built muscle bulk and strength, John found his speed diminished, and injuries occurred. Although the flexibility of joints and the length of ligaments and muscles are determined from birth, stretching can greatly increase the range of movement within a joint. This cannot take place in a ten-minute warm-up stretch: as with strength and stamina, it takes commitment and time to build flexibility. Not all methods of stretching lengthen muscles equally. Jerking or bouncing actions, ballistic stretching, may cause over-stretching. This can adversely affect the supporting ligaments and strain muscles. Movements such as running or hurdling create large amounts of lactic acid, causing stiff, sore joints next day. Stretching, in contrast, produces almost no lactic acid, but directly benefits muscles, joints, and organs.

FOCUSING THE MIND

Relaxing at a really deep level releases tense muscles, but athletes are starting to understand the power of mind over matter, bringing the mind totally into sport as if into meditation. This stretch program, based on hatha yoga, brings the mind and body together, enhancing concentration, and increasing flexibility and stamina with effective breathing. Stretching is most beneficial when performed slowly and precisely, the mind focused on the body and each breath. Even when it is practiced more quickly, the emphasis remains on precision and breathing. Breathing changes with various stretches, offering new insights into the way the body works, and its links with the mind.

Running and Jogging

RUNNING WITH AN EASY fluid action involves the whole body, and to run well, without injuring knees, shins, or ankles, it is crucial to have supple hips and spine. An injury in one part of the body may occur if another area is stiff: balancing the pelvis and spine, for example, can prevent wear and tear on the joints. Repetitive leg action may harm the hips if the pelvis is unbalanced, which can lead to arthritis of the lower back, hips or knees. These exercises help before and after a run, while breathing well increases stamina and brings oxygen to the muscles, reducing the build-up of lactic acid.

AREAS TO TARGET

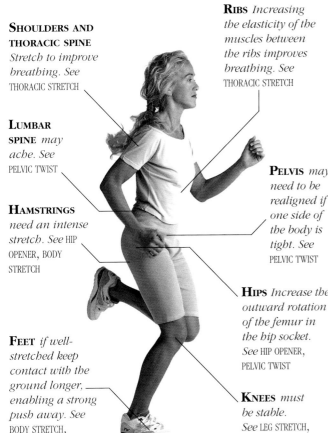

SHOULDERS AND THORACIC SPINE *Stretch to improve breathing. See* THORACIC STRETCH

RIBS *Increasing the elasticity of the muscles between the ribs improves breathing. See* THORACIC STRETCH

LUMBAR SPINE *may ache. See* PELVIC TWIST

HAMSTRINGS *need an intense stretch. See* HIP OPENER, BODY STRETCH

PELVIS *may need to be realigned if one side of the body is tight. See* PELVIC TWIST

FEET *if well-stretched keep contact with the ground longer, enabling a strong push away. See* BODY STRETCH, RECOVERY POSE

HIPS *Increase the outward rotation of the femur in the hip socket. See* HIP OPENER, PELVIC TWIST

KNEES *must be stable. See* LEG STRETCH, ACHILLES STRETCH

THORACIC STRETCH

Stand square to a wall, feet parallel and hip-width apart. Stretch out and place your palms on the wall, shoulder-width apart, your fingers spread. Reach higher if your lower back is stiff. Hold for 30-60 seconds.

Running and Jogging

BODY STRETCH

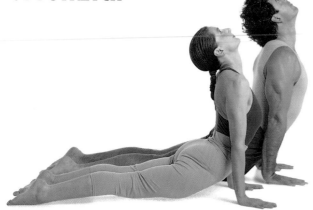
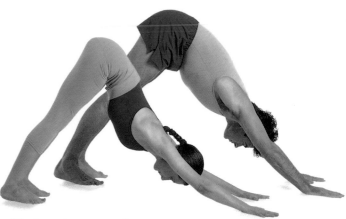

1 Lie face down, hands near your waist and legs stretched back. Breathing out, lift your trunk and legs, straightening your arms and knees. Curve your upper back, and hold for 10 seconds.

2 Breathe out. Lift your hips and stretch your spine back, heels down. Stretch the shoulders. Spread your fingers. Work your arms and hands evenly for 30-60 seconds. Repeat twice.

ACHILLES STRETCH

Arms-width from a partner and grasping her arms just above the elbow, squat with your knees over your toes, hips stretched back. As you push your heels down, keep your shins diagonal. Hold as long as is comfortable.

HIP OPENER

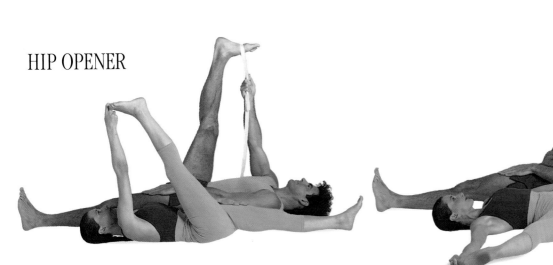

1 Lie on your back. Keeping one leg straight, raise the other leg and catch your big toe. If your hamstrings are stiff, loop a belt around your foot. Straighten the leg to stretch your hamstring.

2 Rotate your raised leg outward, bringing it down to shoulder level. Keep your opposite hip down, your pelvis even. Hold for 30-60 seconds, then repeat the stretch on your other leg.

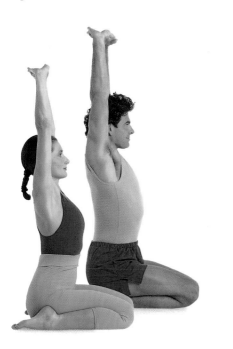

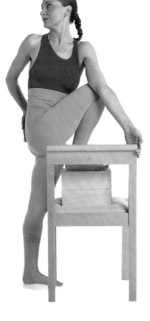

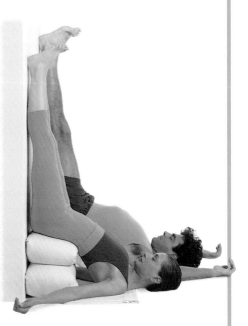

LEG STRETCH

Sit either between your legs or on your heels. Stretch your spine up from your pelvis, interlock your hands and stretch your arms up. Hold for 30-60 seconds, breathing evenly. If your feet are painful, place a rolled blanket under them.

PELVIC TWIST

Place your right foot on a chair, and bring the left arm against the outside of your right thigh. Turn from your lower back, stretching your spine, and looking over your right shoulder. Hold for 20 seconds. Repeat on the other side.

RECOVERY POSE

Relax after a run with feet and legs against a wall, torso supported on cushions, head and shoulders on the floor. Breathe deeply to aerate the body and help concentration, as gravity takes blood toward the heart. Hold for up to 10 minutes.

Football and Rugby

IN CONTACT SPORTS, the days of emphasizing strength and muscle bulk are over. Today's athletes must improve mobility, speed, and range of movement. Flexibility contributes to all these: expanding the range of motion in the joints increases speed and prevents injury. Balancing your time between a daily stretch and weight training helps muscles work more efficiently and easily. If bulky muscles prevent a full stretch, use props such as belts or blocks (see page 19). For a deeper release, stretch with a partner, but be sensitive: let the muscles elongate, and never press directly onto muscles or joints.

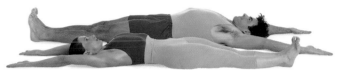

FULL BODY STRETCH

Lie on your back. Lift your arms, and stretch them along the floor behind your head. Lengthen your buttocks toward your heels. Stretch your legs, heels, feet, and toes. Hold the stretch, breathing normally, for 60 seconds.

HAMSTRING STRETCH

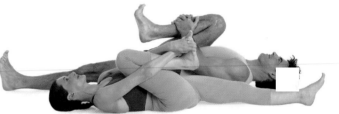

AREAS TO TARGET

SHOULDERS *must relax fully. In the body as a whole, relaxed, easy movement is the key to physical prowess. See* FULL BODY STRETCH

LUMBAR SPINE *should be released. See* HAMSTRING STRETCH, FULL BODY STRETCH

HAMSTRINGS *When these muscles are short, movement in the hips is limited. This can cause back problems. See* HAMSTRING STRETCH, QUAD STRETCH

GROIN AND HIPS *Stretch this area to increase overall range of movement. See* ADDUCTOR STRETCH, QUAD STRETCH, SPINE STRETCH

1 Lie on your back, bend your right knee, and bring it near your trunk. Hold your shin (if flexible, cross your hands and hold your foot). Keep your left leg extended. Change legs.

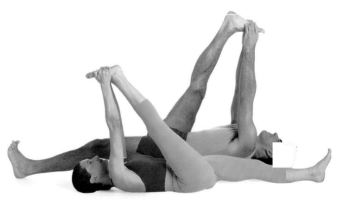

2 Extend your right leg. Gradually draw it close to you. Do not stretch too far. Stretch a little further, and hold. Stretch further, relax, then stretch again until you have stretched as far as is comfortable. Repeat on your left leg.

ADDUCTOR STRETCH

Lie on your back, your feet supported by a block cushioned with a towel. Your partner kneels by your feet and applies gentle pressure evenly to both thighs, rotating them outward. Feel your groin relax as your partner helps you ease into the stretch.

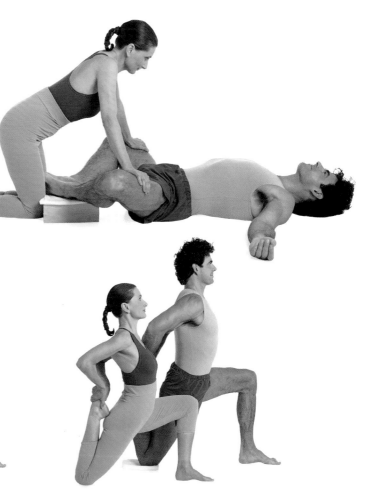

QUAD STRETCH

1 Kneel (on a blanket if you wish). Step forward with your left foot until your shin is vertical. When stable, lunge further forward. Bring your right thigh down, keeping your trunk vertical.

2 If flexible, bend your back leg and catch your foot, drawing it toward your buttock. Hold for 10-30 seconds. Release, and repeat the stretch on your other leg. Then repeat the whole sequence.

SPINE STRETCH

Lie on your back. Bend your knees, and place your feet parallel to each other, near your buttocks. Roll your shoulders back and down. Breathe in, and lift your hips. Lengthen your buttocks toward your heels, and curve your spine. Clasp your hands, then stretch your arms down toward your feet. Relax your face and neck. Hold for 30 seconds. Breathe out. Roll down one vertebra at a time.

Cycling

TO EXCEL IN CYCLING, one of the most popular recreational activities in Europe and America, you need strong leg muscles. Standing stretches strengthen the legs, and inverted stretches rest them. Cycling is an extremely beneficial cardio-vascular work-out, but if your weight is not distributed well over your hands, legs, and buttocks, tension builds in the upper back, neck, and arms. After a long ride, the stretches below reduce stiffness and release the spine. They are most beneficial when used with a daily stretch program (pages 70-75) to aid leg and spine flexibility and develop balance.

AREAS TO TARGET

THORACIC SPINE *can become tense. See* SPINE LENGTHENER, SHOULDER STRETCH, WHOLE SPINE STRETCH, SPINE TWIST

LUMBAR SPINE *Relieve tension here. See* SPINE TWIST, WHOLE SPINE STRETCH

NECK AND SHOULDERS *get stiff with tension. See* SHOULDER STRETCH, ENERGY BOOSTER, SPINE LENGTHENER

ARMS *Stretch out stiffness. See* SHOULDER STRETCH, SPINE LENGTHENER

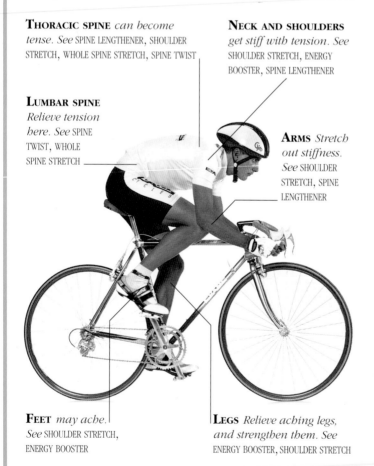

FEET *may ache. See* SHOULDER STRETCH, ENERGY BOOSTER

LEGS *Relieve aching legs, and strengthen them. See* ENERGY BOOSTER, SHOULDER STRETCH

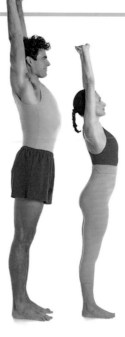

SPINE LENGTHENER

Stand up straight, feet hip-width apart. Ground your weight down into your heels, and stretch your arms over your head, palms up. Extend your spine upward, and relax your shoulders and face. Hold for 20 seconds.

SHOULDER STRETCH

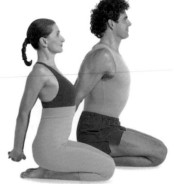

1 Kneel. Sit on your heels. Clasp your hands behind your back. Stretch your arms back. Straighten your elbows. Open your chest, and breathe deeply for 20-30 seconds.

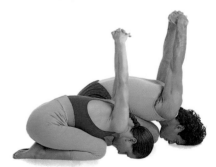

2 On an out-breath, bend forward, buttocks on your heels, stretching your arms back and up. Hold for 10-20 seconds. Come up. Repeat with hands clasped the other way around.

WHOLE SPINE STRETCH

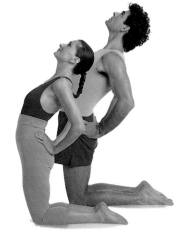

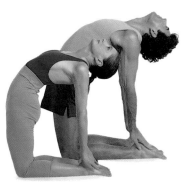

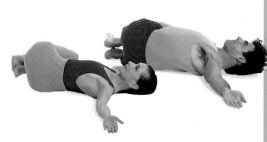

1 Kneel with hands on hips, and stretch your spine. Keep the back of your waist long. On an out-breath, curve your spine back, opening your chest.

2 Keeping your pelvis forward and lifted, place your hands on your heels, and let your head extend back. Hold for 10-20 seconds, breathing normally.

SPINE TWIST

Lie on your back, arms out in line with your shoulders. Bend your knees up. Exhale. Roll your legs to the floor on the right. Hold for 20 seconds. Roll them to the left.

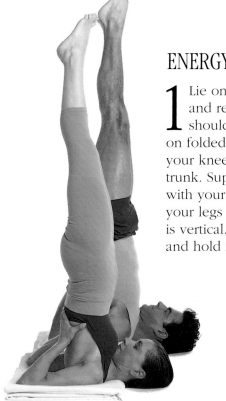

ENERGY BOOSTER

1 Lie on your back, and rest your neck, shoulders, and elbows on folded blankets. Bend your knees, and lift your trunk. Support your back with your hands. Stretch your legs till your trunk is vertical. Breathe easily, and hold for five minutes.

2 Breathing out, lower your legs over your head until your feet rest on the floor (or on the seat of a chair if you are stiff). Keep your spine erect and your hips lifted. Hold for 60 seconds.

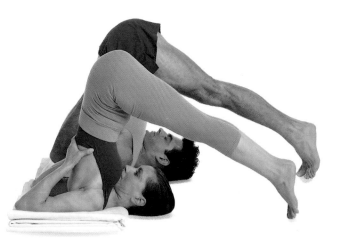

Racket Sports

USING A RACKET can put great strain on the spine, but this problem can partially be minimized by strengthening the abdominal muscles. Improving the rotational range of the shoulders enhances the serve, and increasing all-round flexibility (pages 70-75) boosts speed too. When the shoulders and upper back are flexible, injuries such as tennis elbow are less likely. Mobilizing the hips prevents strains when reaching for difficult ball returns. Standing stretches strengthen the legs and increase flexibility in the hips and lower back. Stretching back counters the crouched posture of squash.

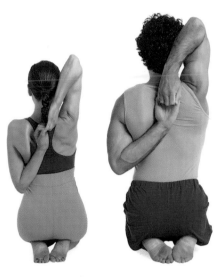

AREAS TO TARGET

HANDS *are vulnerable. Stretch wrists and fingers.* See SHOULDER MOBILIZER, SHOULDER AND WRIST STRETCH, ARM BALANCE

SHOULDERS *Improve service and speed by increasing flexibility and rotation. See* SHOULDER MOBILIZER, THORACIC EXTENSION, SHOULDER ROTATOR

ARMS *Increase rotation and strengthen. See* SHOULDER ROTATOR, SHOULDER AND WRIST STRETCH, ARM BALANCE

SPINE *If supple, injury is less likely. See* THORACIC EXTENSION, SHOULDER AND WRIST STRETCH, SPINE TURN

HIPS *Increase mobility to prevent injuries. See* HIP STRETCH

LEGS *need to be strong. See* LUMBAR AND SACRAL STRETCH, HIP STRETCH

SHOULDER ROTATOR

Sit on your heels. Bend your left elbow so your hand rests vertically on your spine, palm out. Stretch your right hand over your head. Breathing out, bend your right elbow, and catch your hand (use a belt if this is difficult). Hold for 30-60 seconds. Repeat on the other side.

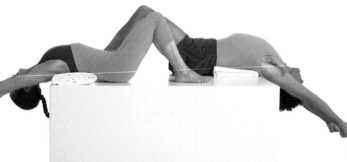

THORACIC EXTENSION

Lie back on a low table, knees bent, shoulders and upper back supported with folded blankets. Roll your head and shoulders off the edge of the table, but not too far. Stretch your arms over your head, your pelvis away from your waist. For more stretch, hold a bar weight. Hold as long as is comfortable (up to five minutes), breathing easily.

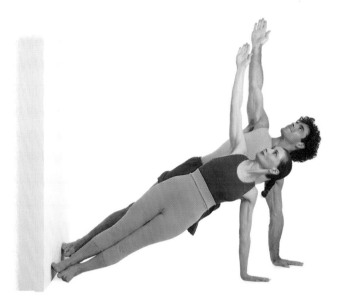

SHOULDER MOBILIZER

Lie on your left side, feet against a wall, right on top of left. Push up from your left hand until your arm is vertical with your shoulder. Stretch your right arm in line with your left, and look up. Hold for 60 seconds, breathing normally. Repeat on the other side.

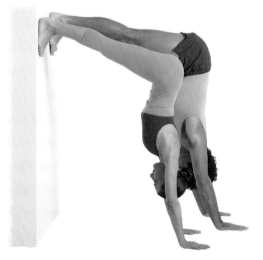

SHOULDER AND WRIST STRETCH

Stand with your back square to a wall and bend foward. Place your hands flat on the floor, spread your fingers, and walk your feet up the wall until your legs are horizontal or higher. Bring your hips in line with your shoulders. Hold for 10-15 seconds.

ARM BALANCE

Place your hands on the floor, close to the wall, shoulder-width apart. Raise your hips, walk in, and spring up, straightening the arms. Lock the elbows. Stretch the shoulders and trunk up, legs straight and strong. Hold for 20-30 seconds, breathing normally.

▷

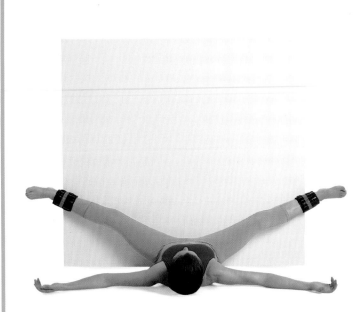

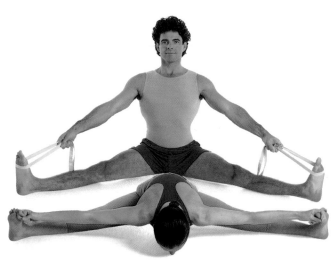

HIP STRETCH

Lie with your hips against a wall, your arms out-stretched. Spread your legs as wide as possible and feel your inner thighs stretch. If your hips are very flexible, increase the stretch by attaching weights to your ankles. Hold for 60 seconds or longer.

LUMBAR AND SACRAL STRETCH

Sit on the floor and spread your legs evenly (sitting on firm cushions if necessary). Stretch your spine from your tailbone to the crown of your head, if necessary using a belt looped around each foot. If flexible, bend forward from your hips, keeping your legs straight, and rest your trunk on the floor or on a bolster. Hold for as long as is comfortable.

SPINE TURN

Sit, on a block if needed, with your left leg straight, your right heel drawn toward your buttock. Place your right hand behind your hips to support and lift the spine. Rotate your trunk to the right, bringing the upper part of your left arm to the outside of your bent leg. Lift and twist the spine. Look over the shoulder. Breathe normally. Hold for 15-30 seconds. Repeat to the left.

Golf

GOOD HIP FLEXIBILITY adds yards to your drive, and strong spine muscles release you from the aches and pains of golf. The twist action of the drive or chip produces aches in the trunk, hips, and knees if the spine is stiff and poorly aligned. Over-using the lumbar arch can put strain on the vertebrae, and keeping the spine supple and muscles toned helps prevent this. If golf is your only exercise, it is more important to stretch each day (pages 70-75). A very stiff upper back, often after hours spent at a desk, can indicate degenerating muscles, ligaments or vertebrae: it is never too late to correct this.

AREAS TO TARGET

THORACIC SPINE
Encouraging this area to move backward balances the spine's curves. See PASSIVE STRETCH, THORACIC LIFT, SPINE TONER

LUMBAR SPINE
Twisting relieves pressure here. See EASY TWIST, HIP AND LEG STRETCH, SPINE TONER, LEG STRENGTHENER

HIPS *may be painful if the body is not flexible. See* LEG STRENGTHENER, HIP AND LEG STRETCH

KNEES *may suffer from stiffness. See* LEG STRENGTHENER, THORACIC LIFT

LEGS *must be strong. See* LEG STRENGTHENER

LEG STRENGTHENER

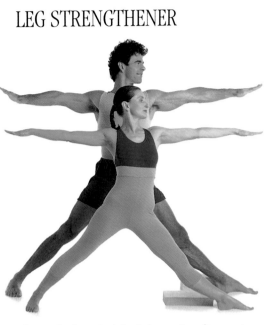

1 With feet 3-4 ft. (about 1 m.) apart, a block by the left foot, stretch the arms. Turn the right foot in, the left foot out.

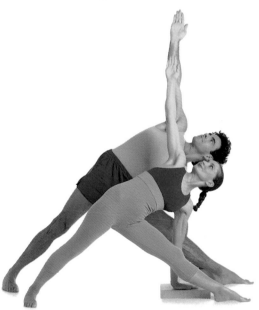

2 Breathing out, extend your trunk to the left (do not bend forward). Place your left hand on the floor by your foot or on the block. Stretch your right arm up and look up. Hold for 30-60 seconds, then repeat on the other side.

117

Golf

HIP AND LEG STRETCH

1 Standing straight, jump your feet 3-4 ft. (about 1 m.) apart, and stretch your arms out at shoulder level. Place a block by your left foot if stiff. Turn your right foot in slightly, your left foot out. Breathe out, and rotate your trunk to the left.

2 Bring your right arm over your left foot and let your right hand rest on the floor or block. Stretch your left arm up in line with your right, and look up at your hand. Hold for 15-30 seconds. Repeat on the other side.

PASSIVE STRETCH

Roll a blanket to the width of your shoulder blades. Lie on your back with your knees bent, and roll your upper back over the blanket so your shoulders drop toward the floor. Sink the back of your waist toward the floor, and, if the lumbar curve lengthens, stretch your legs. Hold for 60 seconds or longer.

SPINE TONER

Lie face down with your arms by
your side, palms up. Breathing
out, lift your head, shoulders, and
legs away from the floor. Stretch
your lower back, and contract
your anal muscles. Hold for a
few seconds, then repeat.

EASY TWIST

Sit on a chair with your hips against
the back. On an out-breath, turn
your trunk to the left, holding
the back of the chair and
turning from your pelvis.
Hold for 15-30 seconds.
Repeat on the other side.

THORACIC LIFT

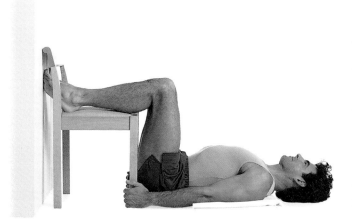

1 Lie on your back with a chair placed in front of
you (by a wall), supporting your shoulders and
elbows with a folded blanket. Bend your knees,
place your feet on the seat of the chair, and hold the
chair legs with your hands. Take a few breaths.

2 On an out-breath, press your feet down on the
seat and lift your hips. Use your feet to lift and
stretch your spine so your upper back extends.
Hold for a few seconds, breathing normally, then
lower your hips to the floor.

Baseball, Softball, and Cricket

EXPLOSIVENESS: HAVING THE ABILITY to move, run, and hit the ball after long periods of inactivity is the key to being part of a winning team. Stretching with a partner is very beneficial, and mental preparation is important too, so take time when warming up to focus on your breathing, becoming aware as you do so of the expansion and release of your diaphragm and chest. The knees are vulnerable in these sports, and hamstring or groin pulls are likely when running for a base or diving for awkward balls. Pay attention to these areas in warm-ups and when stretching after a game.

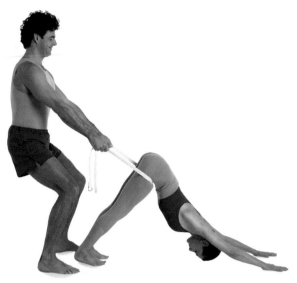

ALL BODY STRETCH

Kneel on all fours, hands and feet hip-width apart. Breathe out. Lift your hips. Stretch back from your hands. Legs straight, push your heels down. Your partner loops a belt around the tops of your thighs and brings your body back, stretching your legs and heels down.

AREAS TO TARGET

THORACIC SPINE
Developing flexibility and strength helps batting. See LONG BACK STRETCH, UPPER BODY STRETCH, STRONG SPINE STRETCH

SHOULDERS *benefit from increased flexibility. See* UPPER BODY STRETCH, ALL BODY STRETCH, PELVIC ROTATION

LUMBAR SPINE
Building strength here improves throwing and batting. See PELVIC ROTATION, STRONG SPINE STRETCH

GROIN *is vulnerable to strain. See* HAMSTRING RELEASE, STRONG SPINE STRETCH

HAMSTRINGS *can pull easily. See* HAMSTRING RELEASE, ALL BODY STRETCH

KNEES *are complex joints and need strengthening. See* ALL BODY STRETCH, UPPER BODY STRETCH, HAMSTRING RELEASE

CALVES
Elasticity is important for running. See ALL BODY STRETCH

ANKLES *must be strong. See* ALL BODY STRETCH

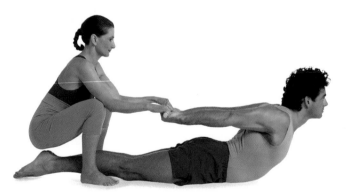

UPPER BODY STRETCH

Lie face down, hands behind your back holding a stick. Your partner squats by your feet. Stretch your arms back, parallel to each other. Let your partner draw your shoulders and upper chest up by lengthening the backs of your arms. Lift your neck in line with your upper back. Hold for 30 seconds.

STRONG SPINE STRETCH

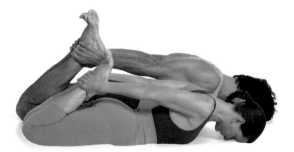

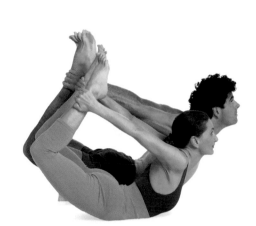

1 Lie face down on the floor. Bend your knees one by one, then reach back and catch your ankles with your hands. Press down on your thighs.

2 Breathing out, pull your legs and upper body away from the floor. Hold for several breaths, release your legs one by one, and repeat.

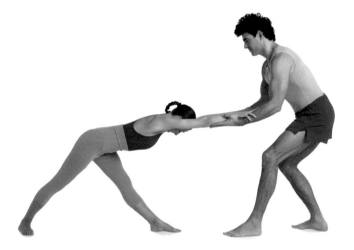

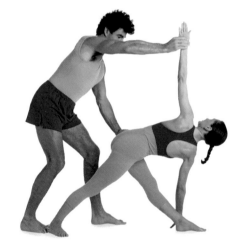

LONG BACK STRETCH

With feet 3-4 ft. (about 1 m.) apart, turn the right foot in, left leg out. Turn the trunk left. Stretch out from the hips, left hip back. Your partner holds your arms, elongating your spine for 30-60 seconds. Repeat right.

PELVIC ROTATION

From LONG BACK STRETCH keep turning left. Take the right arm over the left foot. Extend the left arm. Look up. Let your partner hold the back heel, pull back the left hip and lift the left arm (30-60 seconds). Repeat right.

HAMSTRING RELEASE

Sit with legs stretched out, buttocks on a block if your hamstrings are tight. Stretch up from your pelvis. Breathe out, stretch forward from your hips, and rest your trunk on your legs. Clasp your feet or, if flexible, catch your hands beyond your feet. Hold for 60 seconds.

Basketball, Netball, and Volleyball

SHOOTING IS THE OBVIOUS key to success in court sports, but maneuverability is just as important. Increasing agility and flexibility improves speed for quick, cutting actions and body skills, and an all-over stretch prevents injuries. A basic daily program (pages 70-75), vital for all sports players, provides this. The stretches here strengthen weak spots, such as the ankles, an area prone to strain when changing direction sharply, especially in tall players with their higher center of gravity. Enhancing spine and hip flexibility speeds up actions and responses, protecting all muscles and joints.

HAND STRETCH

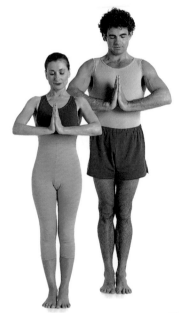

1 Stand or sit with palms together. Stretch your fingers and press your palms strongly together.

AREAS TO TARGET

SHOULDERS *Stretch to develop the throwing action and help prevent injury. See* SHOULDER RELEASE, HAND STRETCH

SPINE *Extending and enhancing flexibility helps protect the whole body. See* SPINE EXTENSION, HAMSTRING LENGTHENER, SHOULDER RELEASE, SPINE EXTENSION

HIPS *Increase flexibility to avoid strains. See* GROIN STRETCH, HAMSTRING LENGTHENER, SPINE EXTENSION

ANKLES *are vulnerable. See* GROIN STRETCH, SPINE EXTENSION

HANDS *Stretching prepares for work with a large ball. Stretch the fingers well in all exercises. See* HAND STRETCH

THIGHS *Develop the inner thighs to avoid tearing muscles. See* SPINE EXTENSION, GROIN STRETCH

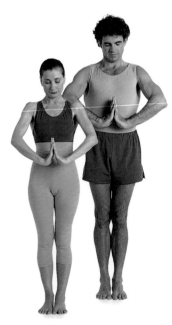

2 Lower your hands, pressing your fingers and upper palms together to create a stretch that extends from finger to wrist. Breathe normally. Repeat two or three times.

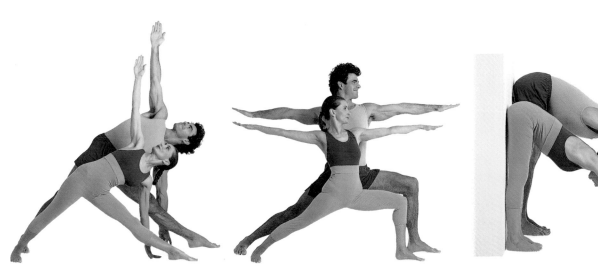

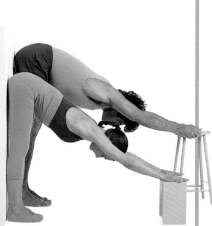

SPINE EXTENSION

With feet 3-4 ft. (about 1 m.) apart, turn the right foot in, left foot out, aligning the left heel with the right arch. Stretch your arms. Breathe out. Extend to the left. Rest your left hand on the floor. Stretch the right arm up. Look up for 20-30 seconds. Repeat on the other side.

GROIN STRETCH

With feet 4-5 ft. (about 1.5 m.) apart, turn the right foot in, left foot out, aligning the left heel and right arch. Stretch up through the spine. Breathe out. Sink your hips, making a right angle with your left knee. Hold for 30-60 seconds. Repeat on the other side.

SHOULDER RELEASE

Stand, hips and heels by a wall, with a stool (low blocks if you are flexible), the length of your outstretched arms and torso in front. Stretch forward to the stool, legs straight. Lift your hips up the wall. Extend from hips to head. Breathe normally and hold for 60 seconds.

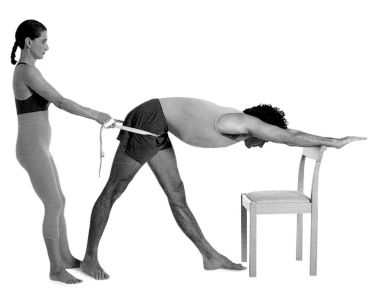

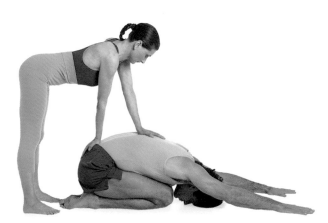

HAMSTRING LENGTHENER

With feet 3 ft. (1 m.) apart, your left foot by a chair, turn your right foot in, left foot out, aligning the left heel and right arch. Your partner puts a belt around your hips and draws the left hip back as you stretch out to the chair for 30 seconds. Repeat on the right.

SPINE RELEASE

Kneel on your heels and bend forward, stretching your arms in front of you. Let your partner push your hips down and stretch your upper spine down toward your head, taking care not to press down on the backbone itself. Hold for 60 seconds.

Weight Training

WEIGHT TRAINING IS VALUABLE for building strength, power, and endurance, but unless you are supervised rigorously when you start out, injuries are likely. The quadriceps and abdominal muscles often become overloaded and the knees strained as they bear uneven pressure. Following a stretching program (pages 70-75) aligns the spine and eases tight muscles, bringing flexibility to the body as you build strength. Leg and hip stretches reduce injury risk; stretching the upper back opens the chest and improves breathing. Using weights as you stretch gives new emphasis to a stretch program.

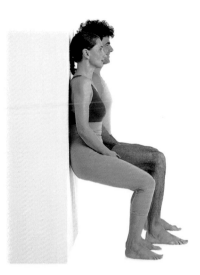

KNEE STRENGTHENER

Stand, back by a wall, feet apart. Knees bent and back straight, slide down the wall. Hold, exhale and descend, knees in line with feet. Lift your arches and ankles and descend in stages until your thighs are parallel with the floor. Hold.

AREAS TO TARGET

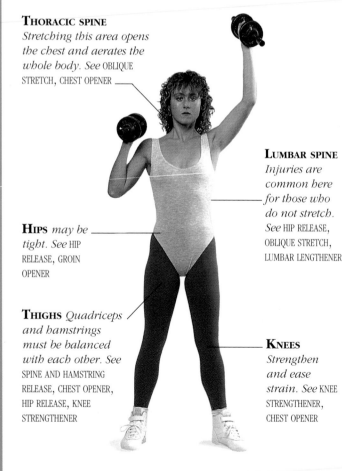

THORACIC SPINE
Stretching this area opens the chest and aerates the whole body. See OBLIQUE STRETCH, CHEST OPENER

LUMBAR SPINE
Injuries are common here for those who do not stretch. See HIP RELEASE, OBLIQUE STRETCH, LUMBAR LENGTHENER

HIPS *may be tight.* See HIP RELEASE, GROIN OPENER

THIGHS *Quadriceps and hamstrings must be balanced with each other.* See SPINE AND HAMSTRING RELEASE, CHEST OPENER, HIP RELEASE, KNEE STRENGTHENER

KNEES
Strengthen and ease strain. See KNEE STRENGTHENER, CHEST OPENER

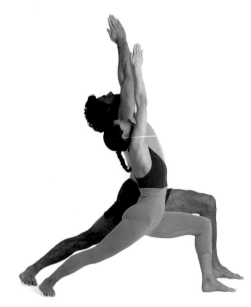

CHEST OPENER

Stand, feet wide, arms up. Turn your right foot in, left foot out, aligning the left heel with the right arch. Turn your trunk completely to the left. Breathing out, bend your front knee. Hold for 30-60 seconds. Repeat on the right.

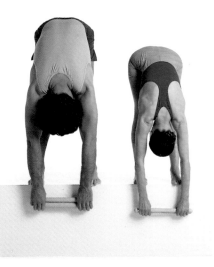

SPINE AND HAMSTRING RELEASE

Stand on a low bench, toes near the edge, holding a bar weight between both hands. Bend forward from your hips and carefully allow your spine to extend as your trunk descends. Keep your knee caps lifted, your legs straight, and breathe normally while you stretch. Hold the stretch as long as you can.

HIP RELEASE

Lie on your back. Raise your right leg, straighten it, and catch your big toe. Rotate the thigh outward and extend the leg toward your outstretched right arm. Rotate your trunk to the left, and release the sacrum toward the floor. Your partner holds your left thigh and hip to help them drop. Repeat on the left leg.

OBLIQUE STRETCH

Lie on your back, arms stretched in line with your shoulders, palms up, a weight on your left hand. Bend your knees to your chest. Breathe out and roll your legs to the right to rest on the floor. Hold for 30 seconds. Repeat to the left.

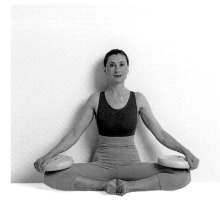

GROIN OPENER

Sit with your buttocks close to a wall, your spine straight. Pull your ankles toward your groin, keeping the soles of your feet together. Relax for 60 seconds or longer, letting your thighs descend toward the floor and your groin open. To increase the stretch, place weights on your thighs.

LUMBAR LENGTHENER

Kneel and sit on your heels, a cushion between your buttocks and heels if stiff. Bend forward, buttocks on heels, and stretch your arms forward. Place one or two weights on the lower back and one in the shoulder blade area to let the spine release. Hold for 60 seconds.

Index

A

B

C

E

F

G

H

I

J

K

L

M

N

Acknowledgments

Author's acknowledgments
Maxine Tobias: To John, whose light has carried me through this creation. My dedication to Yogacharya Sri B.K.S. Iyengar, whose teaching has been my inspiration. A truly great man, his pioneering work in hatha yoga has influenced many systems of human movement.
My thanks to Allan Smith BAhm DOM MIOM for correcting the anatomy and making valuable suggestions for the text.
John Patrick Sullivan: To my beloved Maxine, who made this dream come true.
We both wish to thank Susannah Marriott and Tina Hill, who have worked with patience and dedication, and Tim, Jenny and Barnabas.
All enquiries to Maxine Tobias and John Patrick Sullivan, PO Box 1454, London SW7 3PR.

Dorling Kindersley
would like to thank Carole Ash for overseeing the design at the end of the book; Sarah Ponder for design assistance and the illustrations on pages 16, 70, 72, 74, 92, 94, 96, 98, 100, 102; Vanessa Hamilton and Jane Cooper for design assistance; Sue Michniewicz, Salvo Tomaselli and Colette Cheng for Macintosh design assistance; Barnabas Kindersley for assisting Tim Ridley; Hilary Bird for the index; Beverley Vas at Splitz, Theatrical Hosiery Company, London SW4 for the leotards; Champion Fast Lane Sports, Champion Sports and Slick Willies for lending clothing and props for photography; Philip Szaniszlo for making the wooden props; Dr. Allan Smith for checking the text; and all our models: Jane Beeson, Clara Buck, Barnabas Kindersley, Colin Neville, Gary Pleasants, Edward Saperia and Allan Smith.

Photography
All photography by Tim Ridley, except: pages 8-9, 20-21, 76-77, 90-91, 104-105, 128 by Michael Dunning; pages 110 bl, 120 bl, 122 bl by Sarah Ashun; pages 112 bl, 124 bl by Philip Gatward; pages 114 bl, 117 bl by Matthew Ward.

Hair and make-up
Jenny Jordan; additional hair and make-up by Suzz Keith and Jackson.

Further reading
Light on Yoga B.K.S. Iyengar (Schocken)
Stretch and Relax Maxine Tobias and Mary Stewart (The Body Press, a division of Price Stern Sloan)
Yoga the Iyengar Way Silva, Mira, and Shyam Mehta (Knopf)

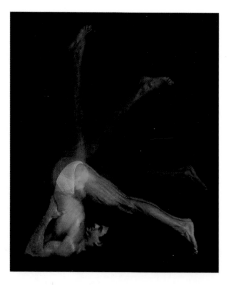